This book is dedicated to my mom and dad for bringing me into this world and forming who I am.
Thank you to all who have helped, you know if you did...and if you didn't help, so be it.

First published in the United States of America
by Rizzoli International Publications, Inc.
300 Park Avenue South, New York, NY 10010
www.rizzoliusa.com

Big Shots

© 2017 Phillip Leeds with introduction Pharrell Williams

Book design by Bill McMullen

For Rizzoli International Publications:
Editor: Ian Luna
Project Editors: Monica Adame Davis & Meaghan McGovern
Production: Maria Pia Gramaglia & Rebecca Ambrose
Design Coordination: Kayleigh Jankowski
Proofreader: Mary Ellen Wilson

Publisher: Charles Miers

Printed in China

2017 2018 2019 2020 / 10 9 8 7 6 5 4 3 2 1
Library of Congress Control Number: 2016958875
ISBN: 978-0-7893-3264-6

PHILLIP LEEDS

BIG SHOTS!

RIZZOLI
NEW YORK

New York Paris London Milan

Children always want their parent's things. My son Theodore always wants my phone or tablet; he has his own equivalent, but wants mine. When I was young, there were no cell phones or tablets. The objects that I gravitated towards were my father's Nikon F, his stainless steel Timex, his ZERO Halliburton silver briefcase, his Polaroid SX-70. These were the coolest things I had ever seen and was not allowed to touch. This memory, along with the insane black-and-white photography collection my father has been relentlessly amassing since before I was born, is where my love of photography started. Ansel Adams, Berenice Abbott, Alfred Eisenstaedt, and Walker Evans graced the walls of my childhood home.

I never considered "being" a photographer. Despite being a very artistic kid, art, as a career choice, didn't seem to be a viable option. My father made his living as an artist manager, guiding the careers of musicians and visual artists from the '60s through the '80s. His firsthand knowledge of how difficult it is, even for the most talented artists, to gain recognition and financial success rubbed off on me. Still, I never lost the desire for that Nikon, and when I was 12, I got one for my birthday. Thus began one of my only longtime hobbies. A few years later I had the opportunity to be a photography counselor-in-training at an amazing summer camp in Connecticut called Buck's Rock. Half camper, half counselor, I learned basic darkroom techniques and became familiar with my Nikon. As I got older I really took a liking to Polaroid cameras. I loved the instant gratification of seeing if you "got the picture" within minutes of taking it and that the photo was a "one of one." In the same way the warm sounds of vinyl records, with the crackles of time and love, add character to music, the imperfections of film and the vintage camera enhance the feeling of the photos. This was way before digital cameras took instant gratification to a whole new level and made imperfections optional.

In college, my love of all things vintage and antique, which I get from my mom, took me to many garage sales and thrift stores and I began collecting vintage Polaroid cameras. Fast-forward through a lot of Polaroid 667 and 669 film to 2004, when I went to an opening for an Andy Warhol exhibition called *Warhol: Red Books*. It was a display of Andy's Polaroid portraits, in conjunction with the release of the box set of books of the same name, which replicated the way he

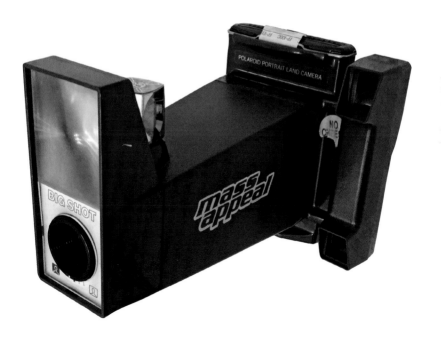

had kept his portraits in red Halston photo albums. At the end was Andy's Polaroid Big Shot camera, which he had used to shoot all the portraits in the show. The Big Shot is one of the most unusual-looking cameras you will ever see.

The Big Shot was made in 1971 by Polaroid, and despite being made of lightweight molded plastic, it was bulky and of limited use, as it is a fixed-focus portrait camera. With disappointing sales, it was discontinued after one year. So I went home and bought a used one off the Internet and began shooting portraits of friends who would come to my house. At the time, I was working as a tour manager for Kelis, N.E.R.D, and Pharrell. I would always travel with a lot of cameras, but the Big Shot stayed at home, being too bulky to travel with. In 2006 I stopped touring and began working for Billionaire Boys Club. I kept the Big Shot at the showroom, taking pictures of people who visited. I shot Snoop, Chris Brown, André Leon Talley, Tyler the Creator, DMC, and Jasmine Sanders at the original New York City showroom. All the while, I had *zero* aspirations for the photos beyond having them for myself. Snoop was the first person to ask me, "Why don't you have a book deal? You should definitely make a book" . . . so I asked him to be my book agent (he declined).

Several years later, in 2013, I met Ian Luna from Rizzoli. We discussed the photos and eventually began to talk about this project. It was at that moment I starting thinking about these portraits differently. Appreciating the access I had to such an amazing and extremely diverse group of people.

This book is an amazing, completely unplanned opportunity that I am truly fortunate to have stumbled into. I am constantly crossing paths with other amazing people to photograph, and this project will continue long after this book has been published. As it was in the beginning, Phillip taking pictures for Phillip.

Phillip Leeds

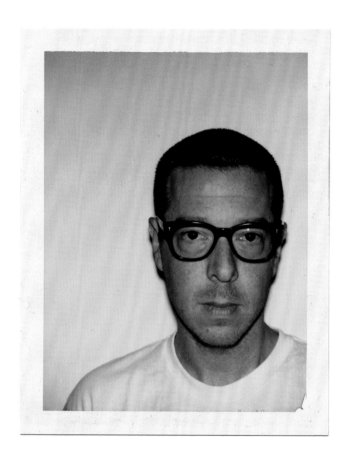

PHILLIP LEEDS by JONATHAN MANNION
with the POLAROID BIG SHOT

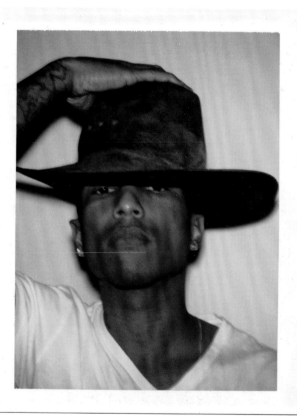

"We should take a picture of this moment."

It's so weird. So many times in life we hear a voice inside saying that. But more often than not, we fail to capture that moment.

I met Phillip way back, in '95 or '96, and he was always the guy who would say, "Let's take a picture."

He navigated a variety of circles and reliably assumed the role of crew documentarian in all of them. But not by trade as much as by circumstance: I guess you could say that he had a firm grasp of what made for that "decisive moment" because he was always right there. In his signature glasses, with a joint in one hand and a complicated vintage camera in the other—a spot-on police description of the dude responsible for all the exotic aromas that emanated from backstage at all our shows.

Maybe he had better vision than all of us.

He had a heightened perspective, a sense of elevating what seemed at the time to be an awesome but altogether inconsequential and fleeting moment. He saw in it something tangible and classic. Something not subject to differences of opinions, eroding details, or, worse, failing memories.

It's there. It is. You can hold it. You can show it to your friends and ask them: "Remember this?"

He's managed to hold on to these moments. Two decades of them. In their thousands. In tidy boxes. Pristine. Fresh. All of them framed in the way he always has.

"Phillip, you're like a photographer…"

"This book is really happening."

"Wait. Am I really writing this?"

[…]

"Phil, lemme borrow your glasses!"

—Pharrell Williams, Los Angeles, September 2016

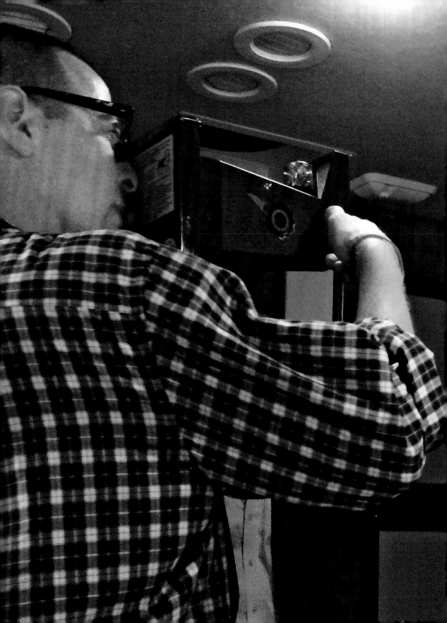

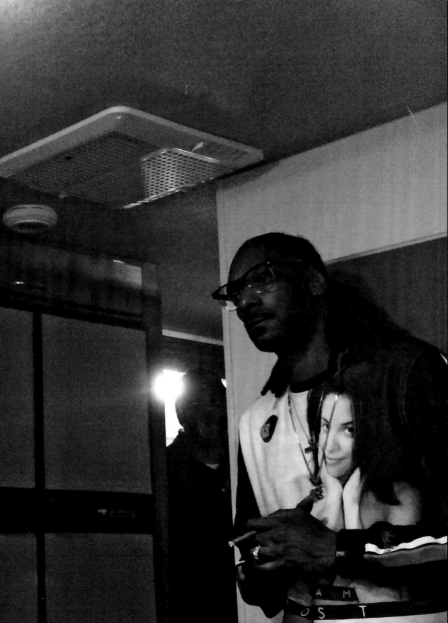

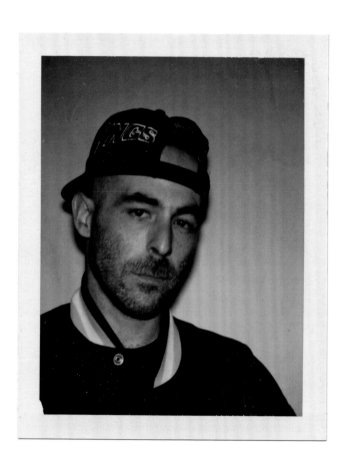

THE ALCHEMIST

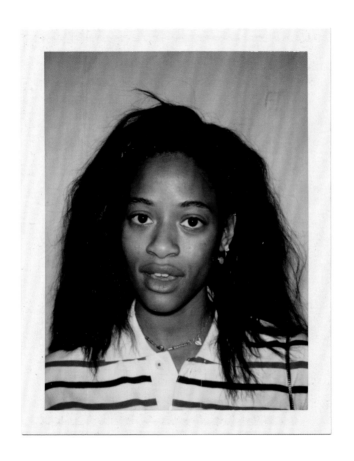

KILO KISH

14

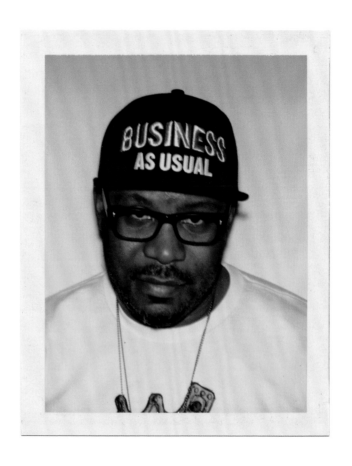

EMORY "VEGAS" JONES

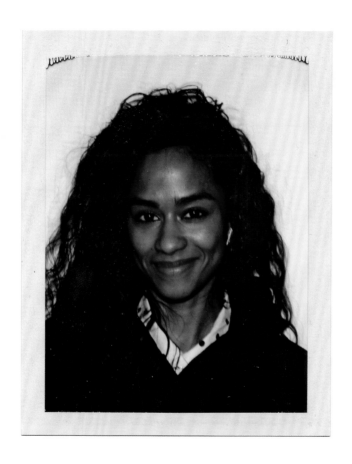

VASHTIE KOLA

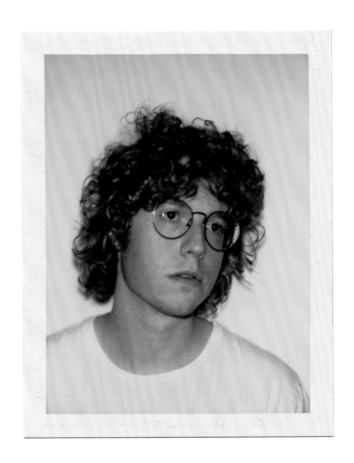

DAVID ANDREW WALLACH

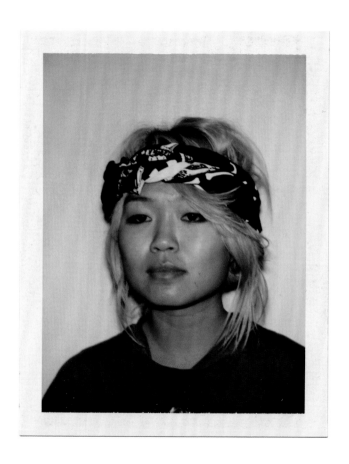

CYNTHIA LU

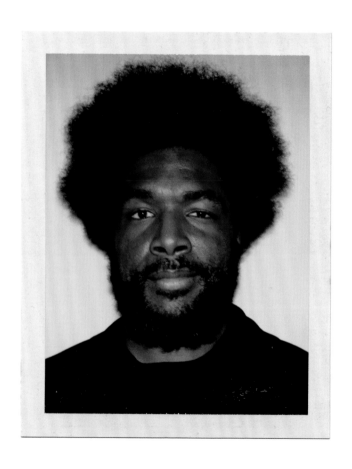

AHMIR KHALIB THOMPSON / ?UESTLOVE

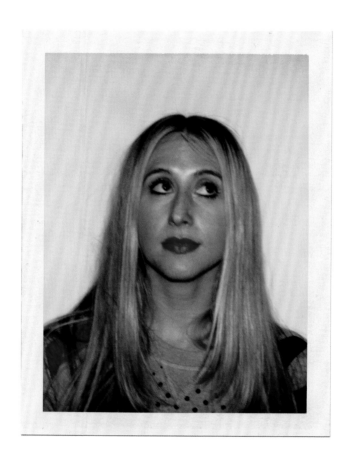

SAMANTHA CHERTOK

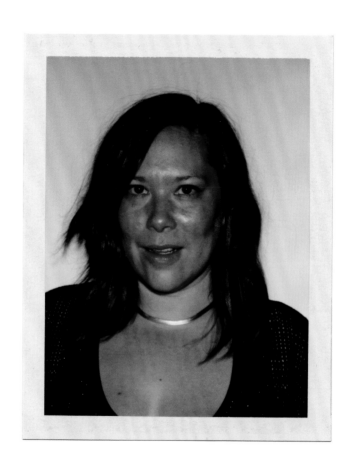

MINYA QUIRK

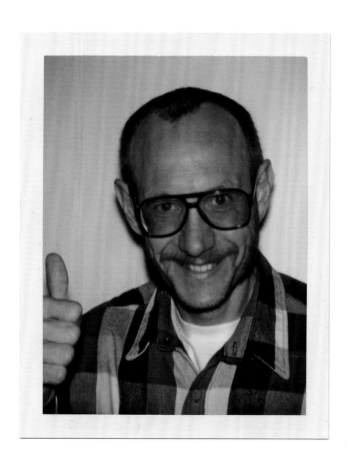

TERRY RICHARDSON

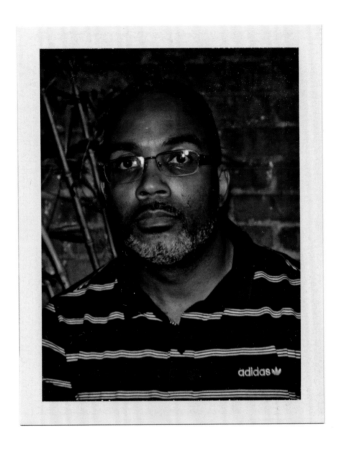

LARGE PROFESSOR

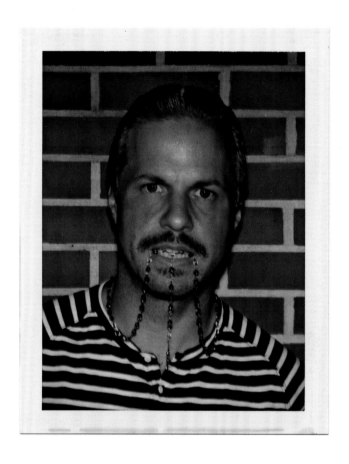

ANTONIO SCARLATA

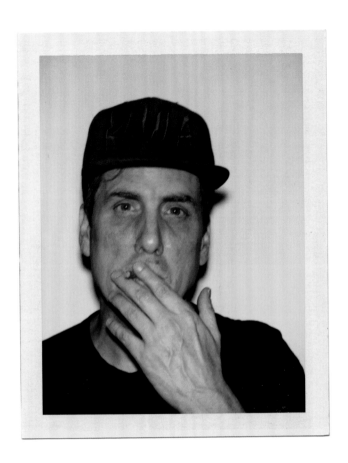

MIKE DEAN

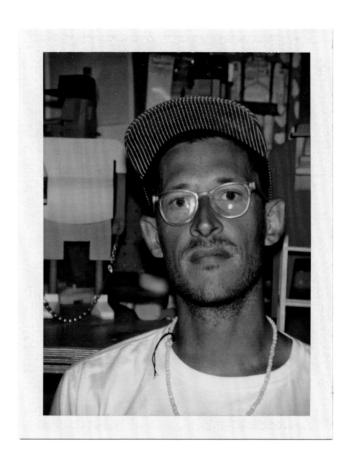

KIMOU MEYER - GROTESK

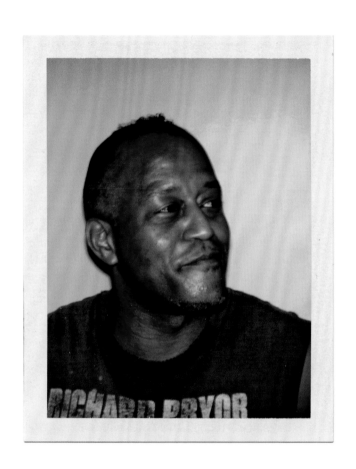

DOMINIQUE TRENIER

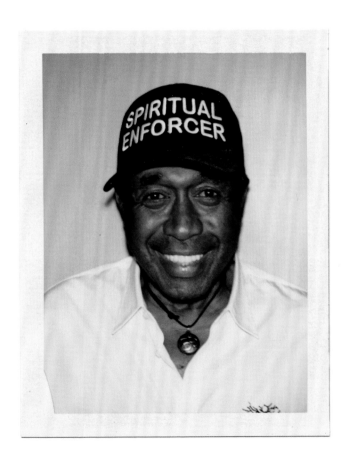

BEN VEREEN

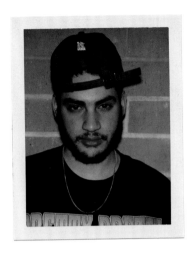
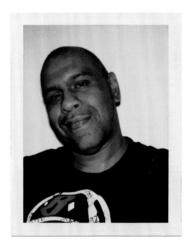
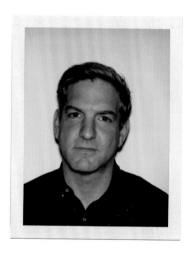

DJ TREATS JOEL POPOTEUR
ALL - CITY SHA NOAH SHACHTMAN

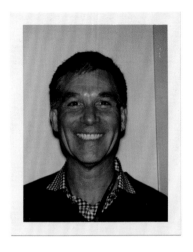
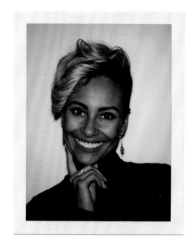
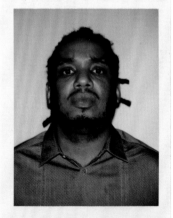
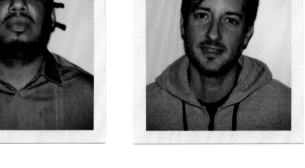

RON LAFFITTE
MARK KELLY

RHEA DUMMETT
PETER BITTENBENDER

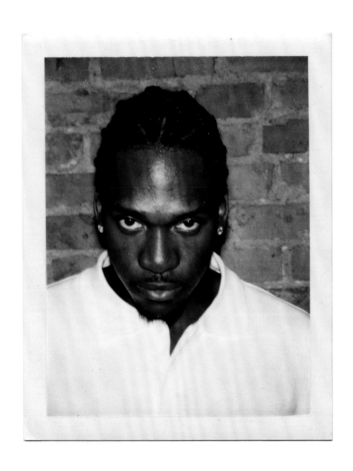

PUSHA T

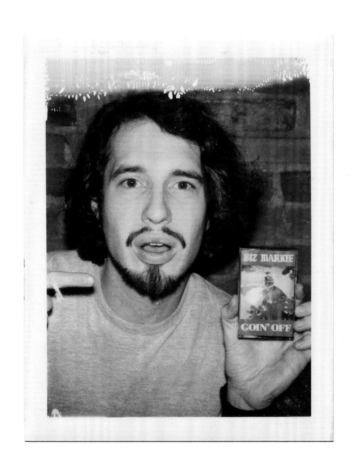

MR. ELEMENT

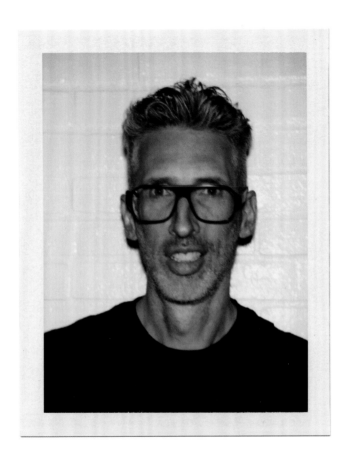

STRETCH ARMSTRONG

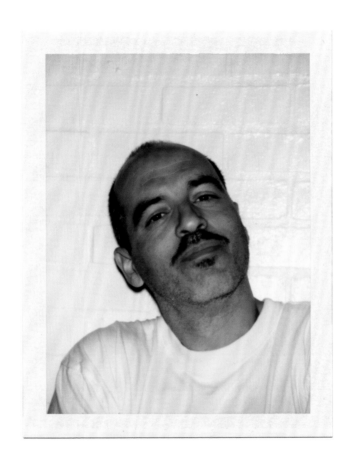

BOBBITO GARCIA

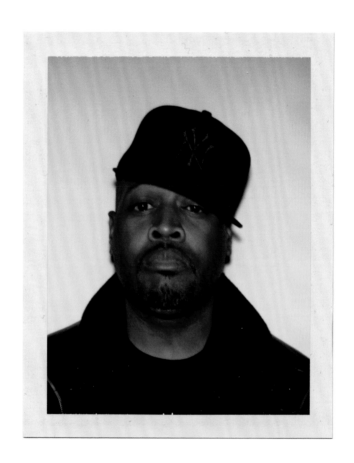

DJ CLARK KENT

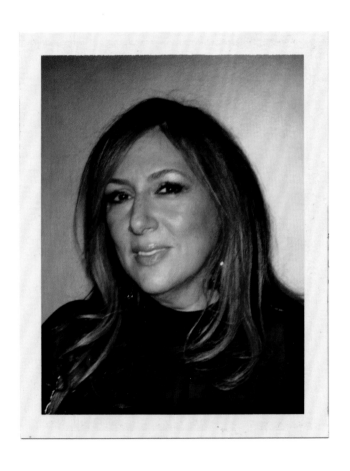

LORRAINE SCHWARTZ

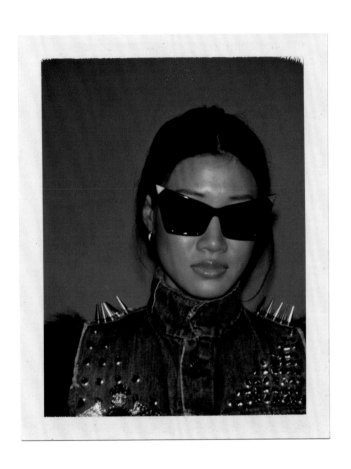

YOON-AMBUSH

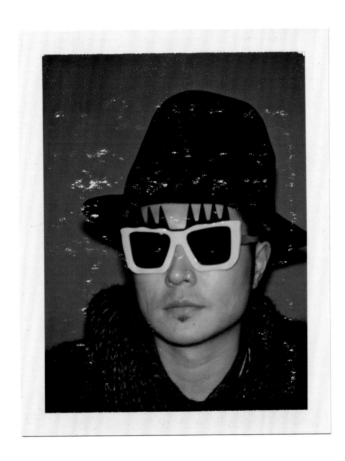

VERBAL-AMBUSH

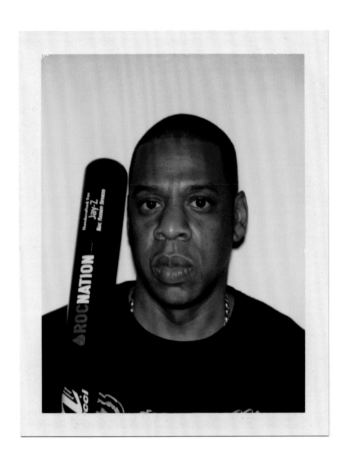

JAY Z

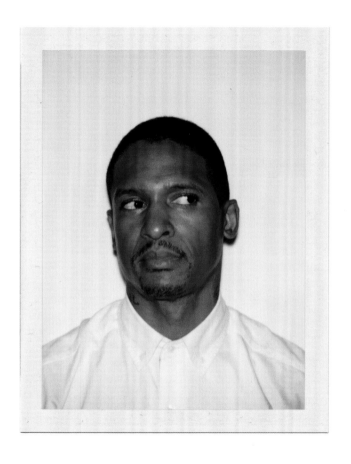

JAMEEL SPENCER

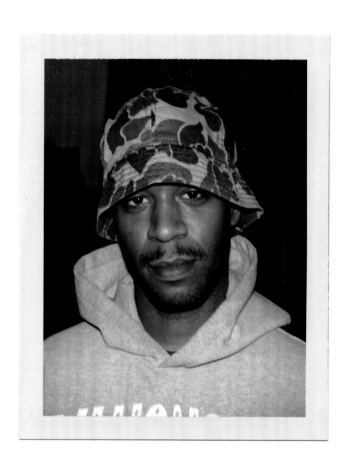

KID CUDI

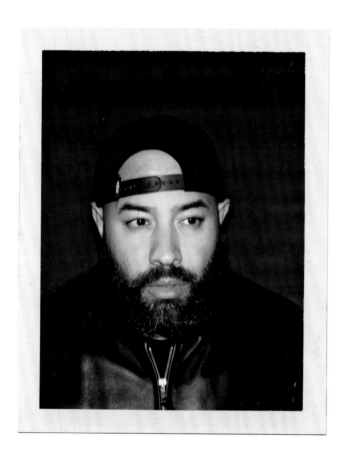

EBRO

42

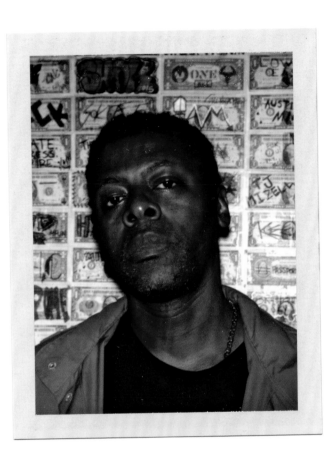

CHI MODU

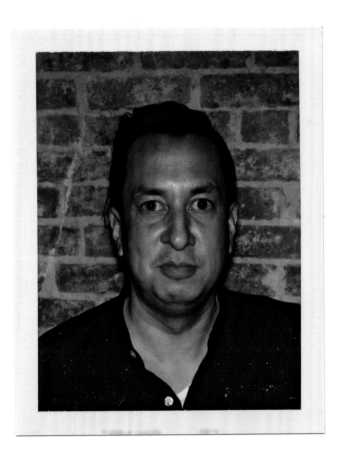

CRAIG COSTELLO

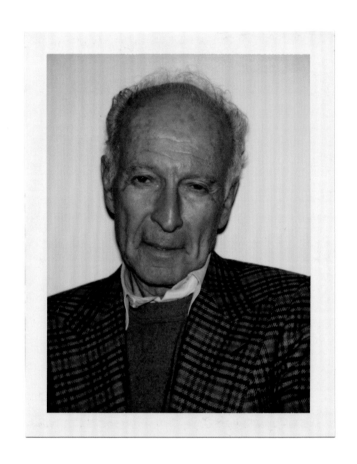

RON DELSENER

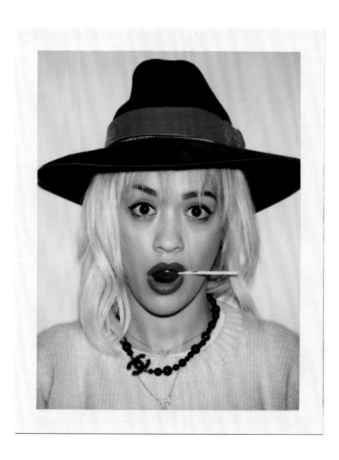

RITA ORA

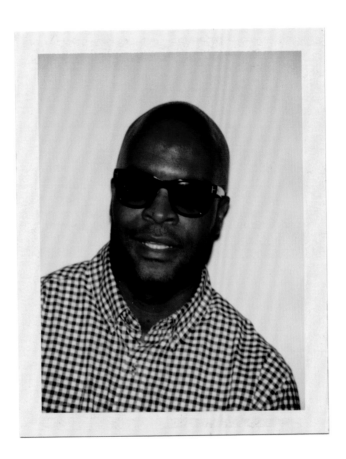

ROB WALKER

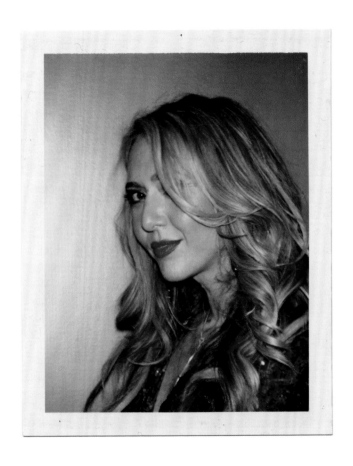

OFIRA SANDBERG

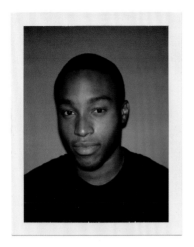

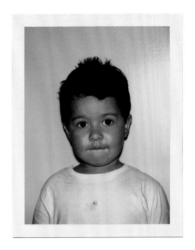

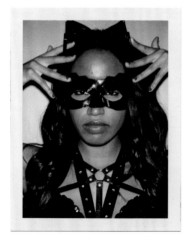

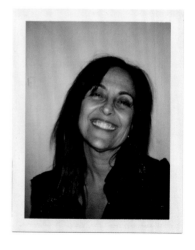

CASSELL FERERE

MYSTERY DANCER

THEODORE LEEDS

LEILA STEINBERG

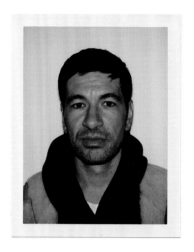

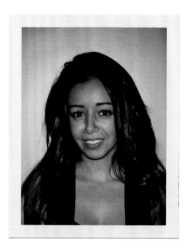

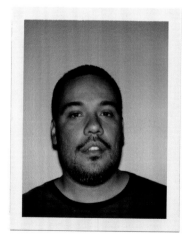

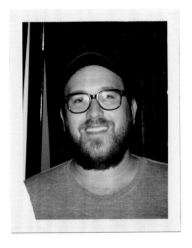

TOBY FELTWELL

WAFAA NAKKOURY

WHAT THE HEC - HECTOR

BEN LEVINE

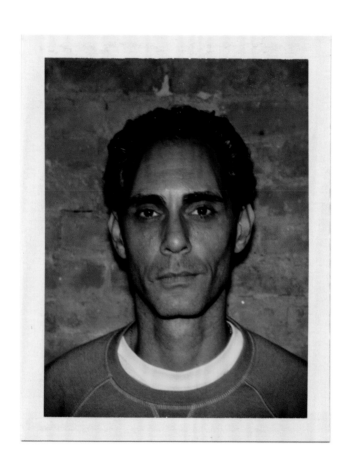

TONY ARCABASCIO

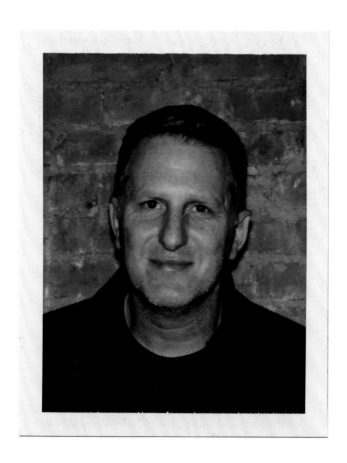

MICHAEL RAPAPORT

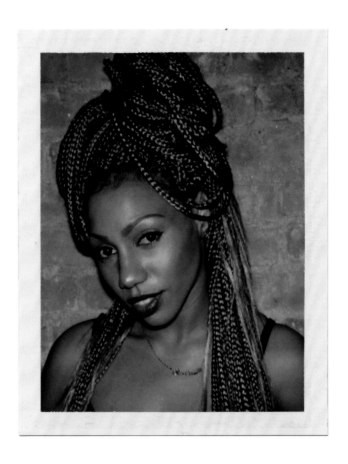

ROXANNE BROWN

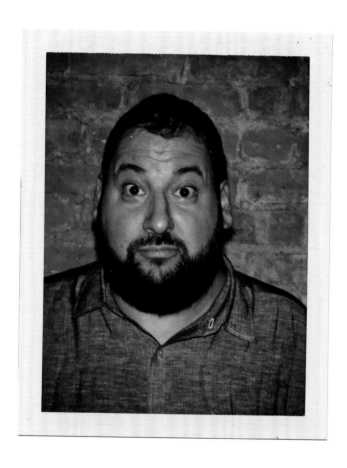

BILL SPECTOR

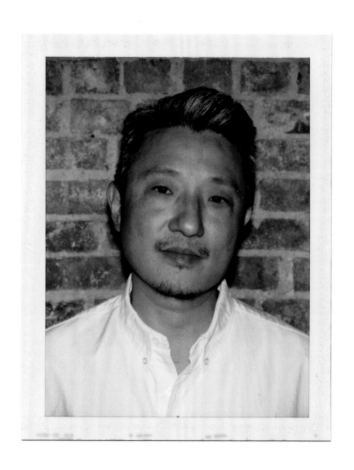

ROMON YANG - ROSTARR

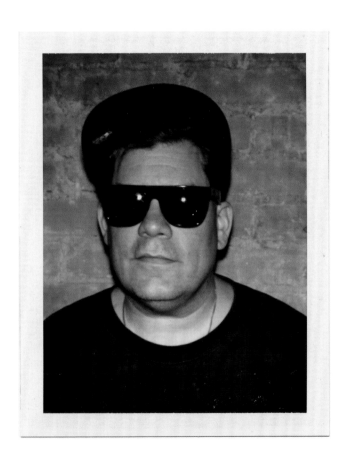

TODD JAMES - REAS

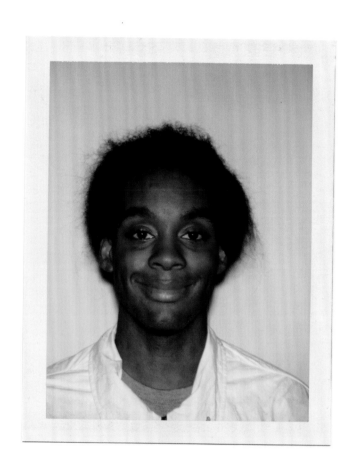

DEE JACKSON

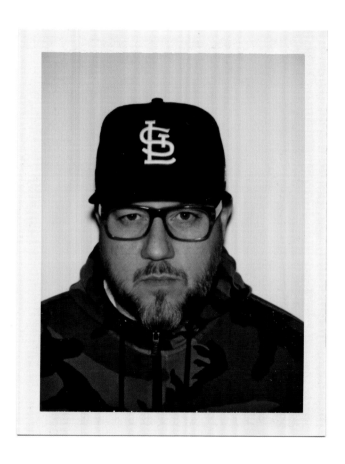

JONATHAN MANNION

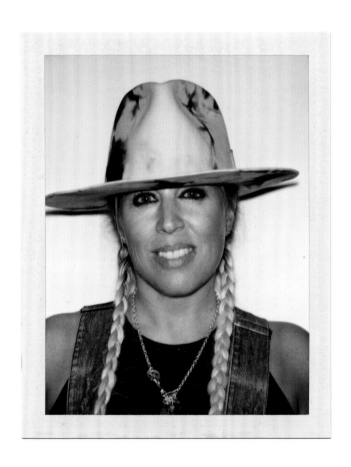

ANNE-MARIE DACYSHYN

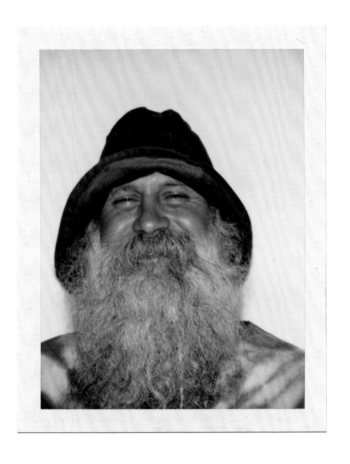

GREG DACYSHYN

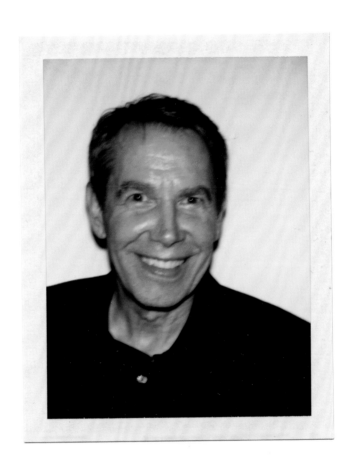

JEFF KOONS

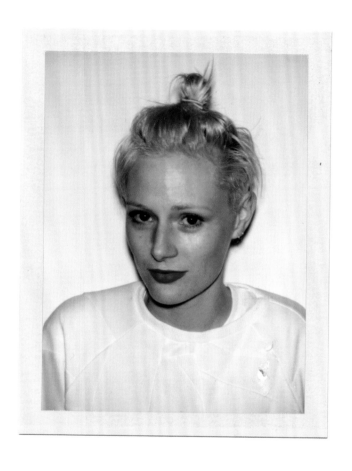

LOUISE DONEGAN

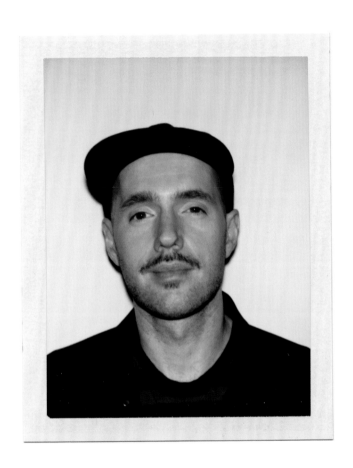

MICK BATYSKE

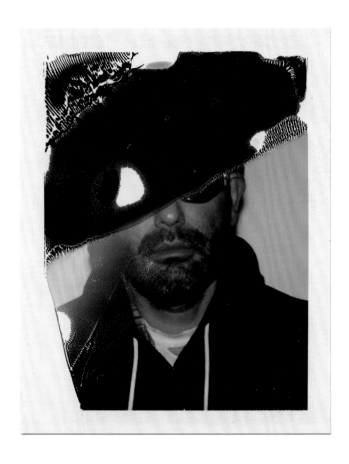

HARIF GUZMAN - HACULA

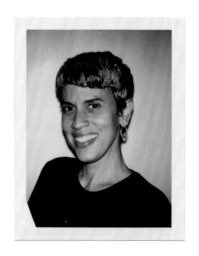
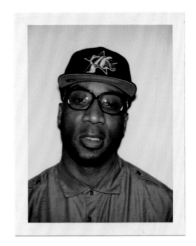
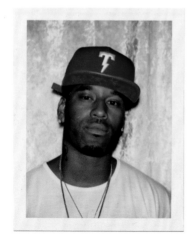
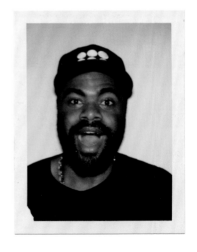

MIMI VALDES　　　　　　FRANK "KNUCKLES" WALKER
P REIGN　　　　　　JERRY EDOUARD

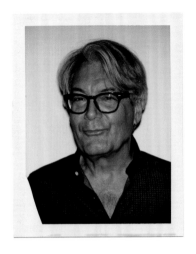

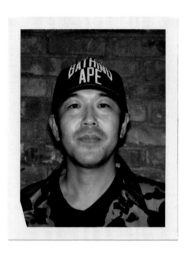

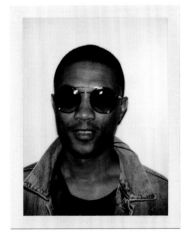

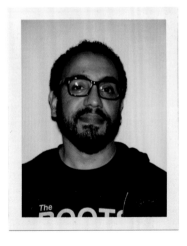

WIM STOCKS
IBN JASPER

MASATO TAKEI
KEITH McPHEE

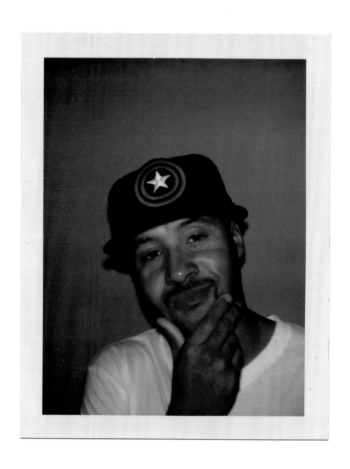

KOFI

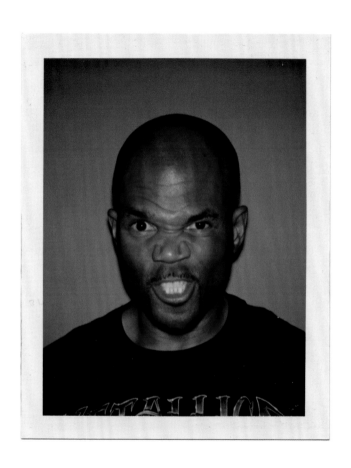

DARRYL McDANIELS - DMC

68

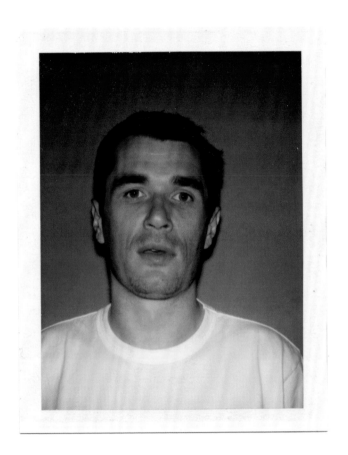

CRAIG FORD

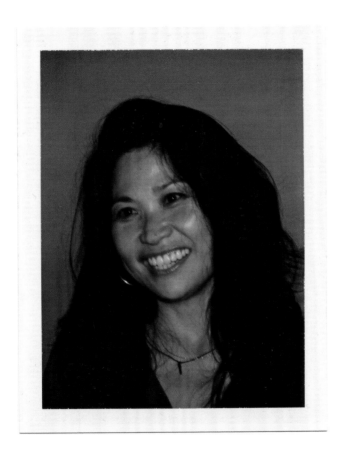

SUE KWON

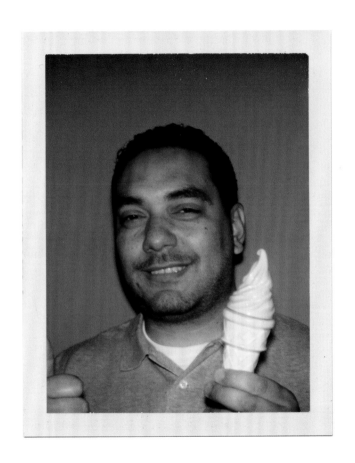

CIPHA SOUNDS

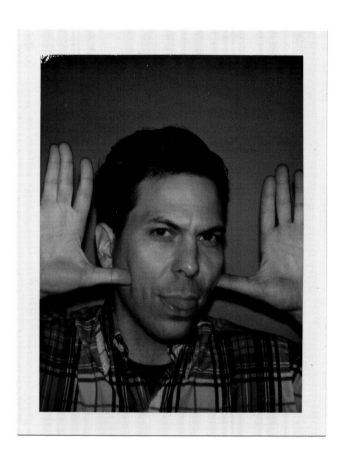

ARI SAAL FORMAN

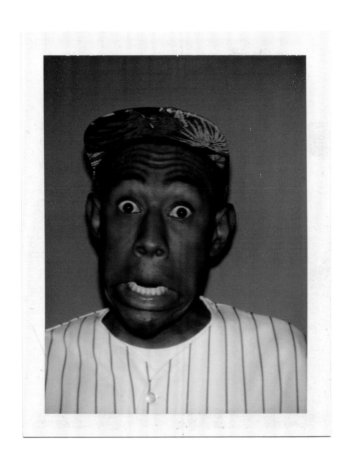

TYLER THE CREATOR

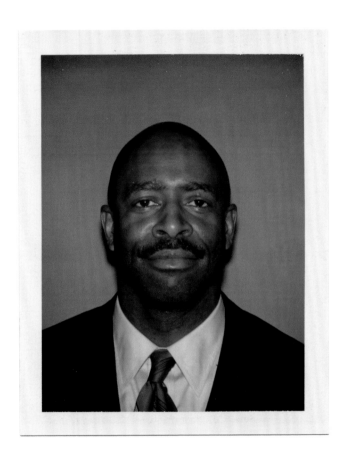

LELAND MELVIN

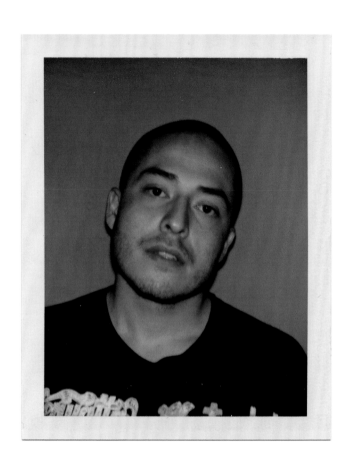

GOGY ESPARZA

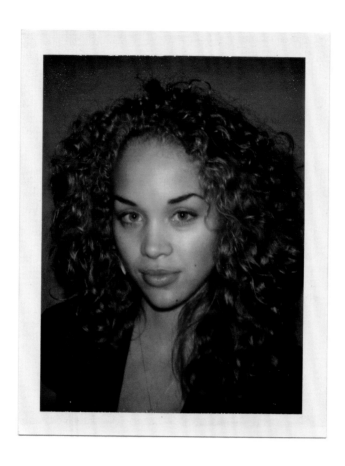

JASMINE SANDERS

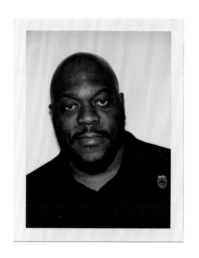
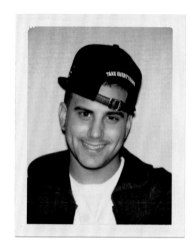
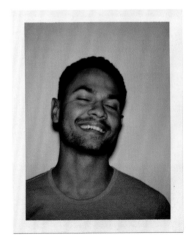
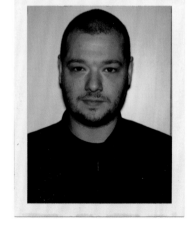

BEN EDWARDS

BRANDYNE LACKLAND

HIP HOP MIKE

JOHN JDM McPHETERS

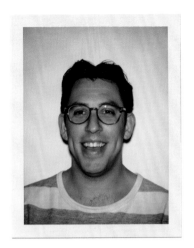

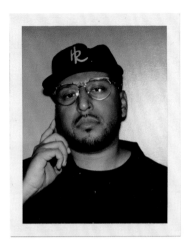

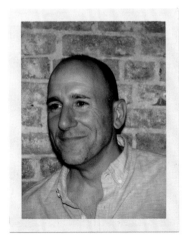

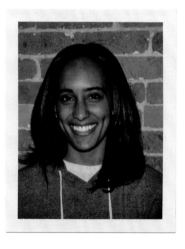

MARK ZABLOW 40oz VAN

BRIAN STRNAD EDEN MARLEY

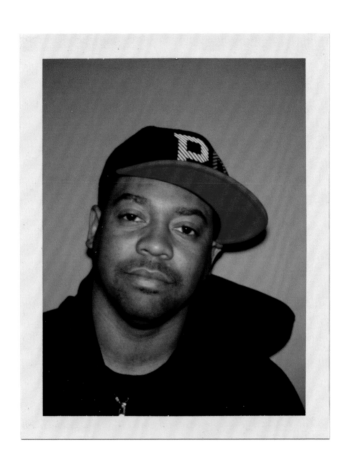

FAM LAY

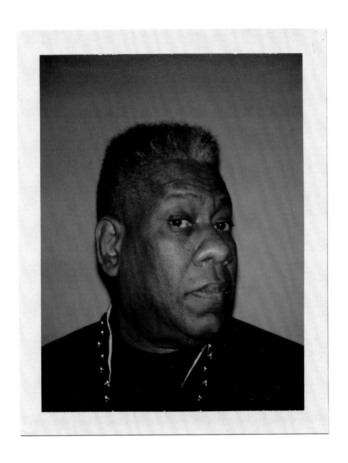

ANDRÉ LEON TALLEY

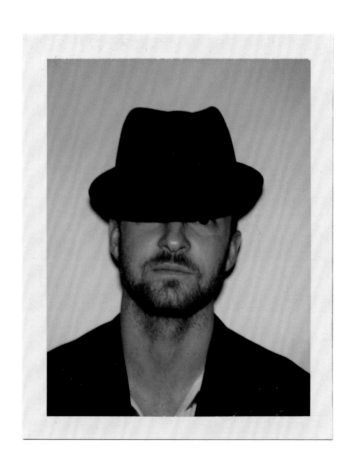

JUSTIN TIMBERLAKE

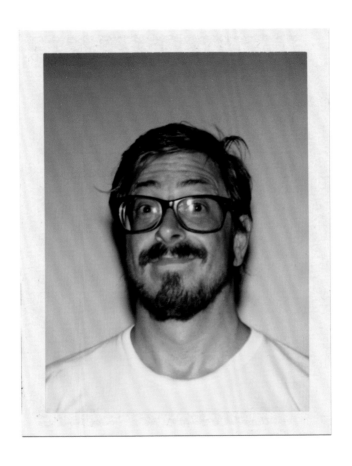

ELI MORGAN GESNER

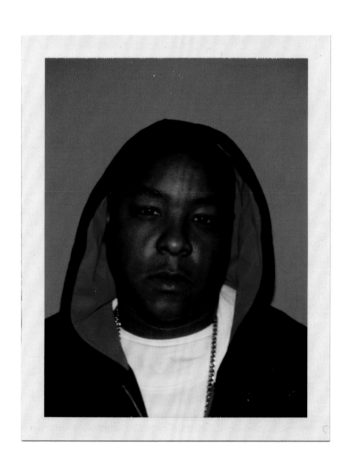

JADAKISS

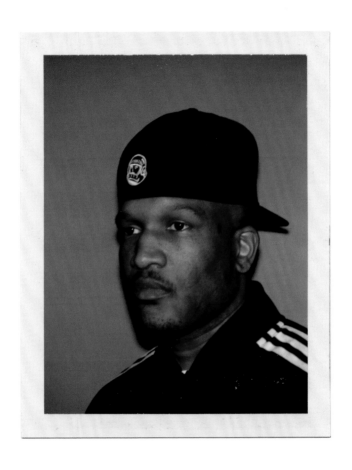

JAY "ICEPICK" JACKSON

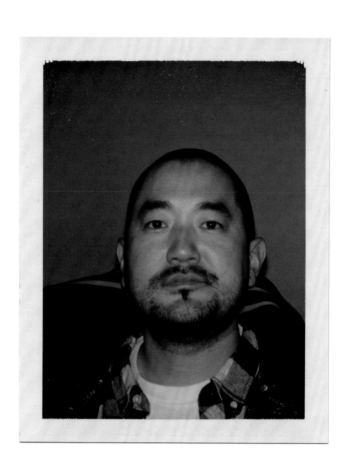

TED CHUNG

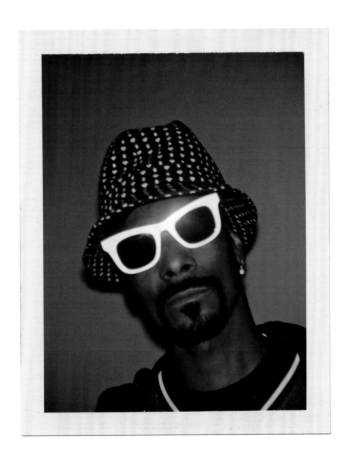

SNOOP DOGG

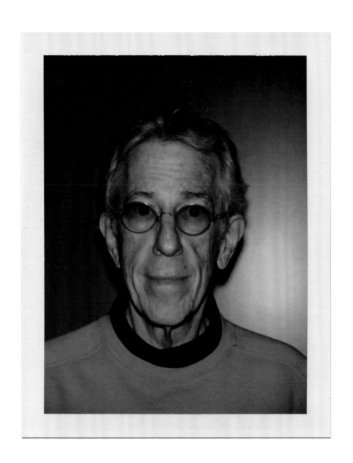

PETER LEEDS

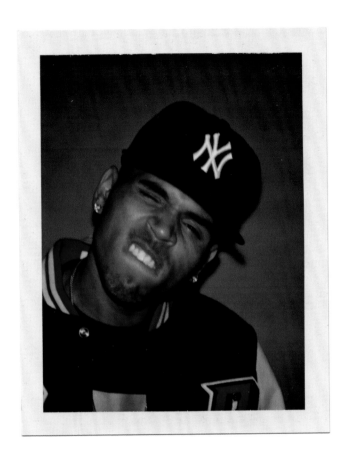

CHRIS BROWN

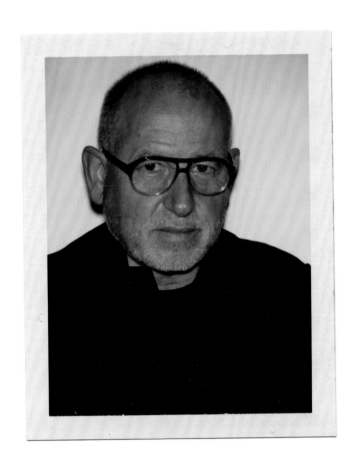

FABIEN BARON

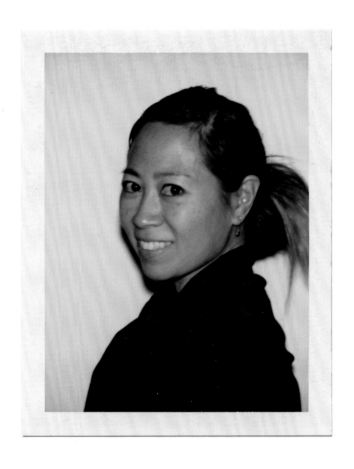

YUKI IWASHIRO

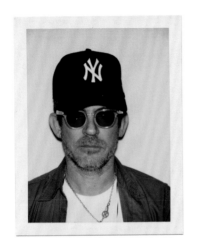
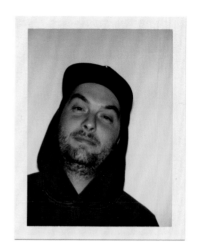
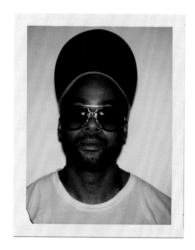
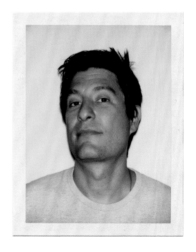

MARK McNAIRY
LITRO

VICTOR MICHAEL
ZACK KURLAND

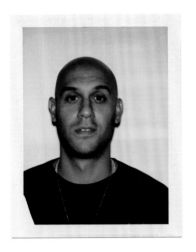
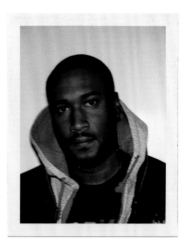
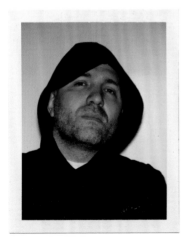
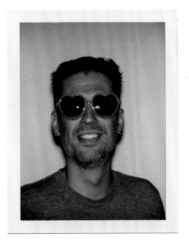

MR. FLAWLESS

MARCUS A CLARKE

NOAH RUBIN

BUFF MONSTER

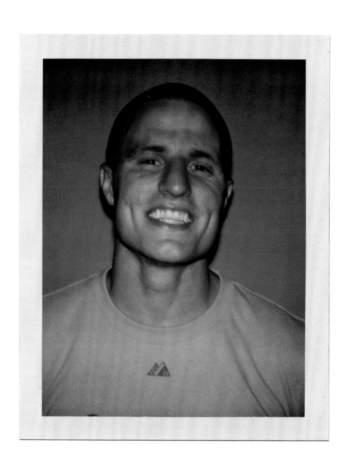

JIMMY GORECKI

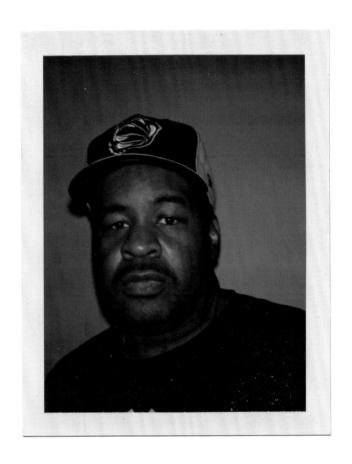

ANTHONY "ANT LIVE" BARRIER

94

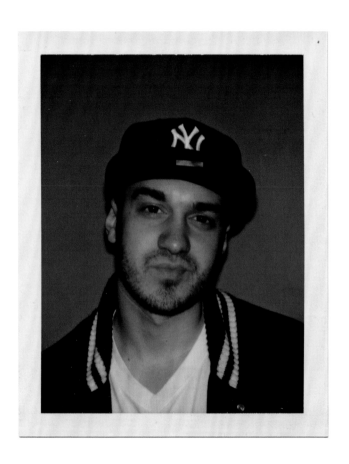

EMILIO ROJAS

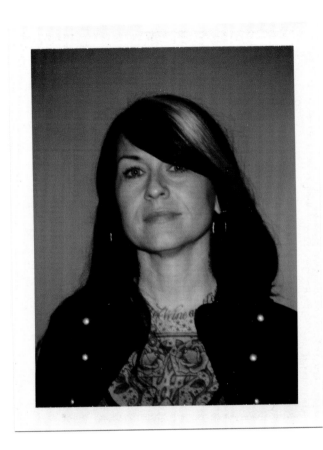

LISA BROWNLEE

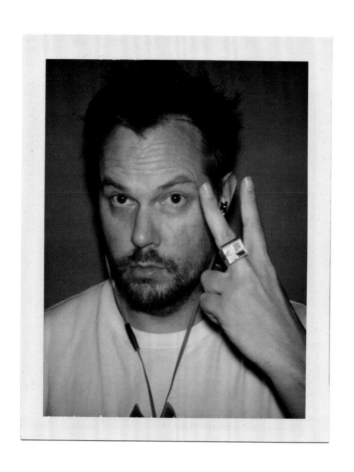

BILLIONS McMILLIONS

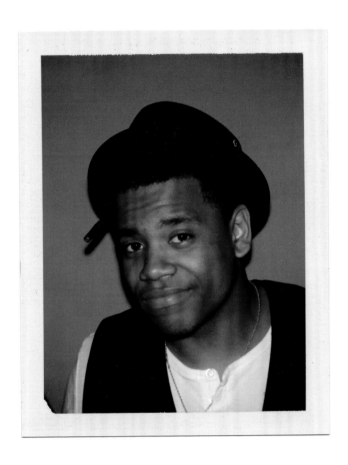

MACK WILDS

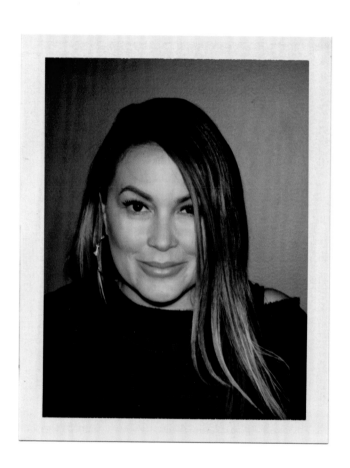

ANGIE MARTINEZ

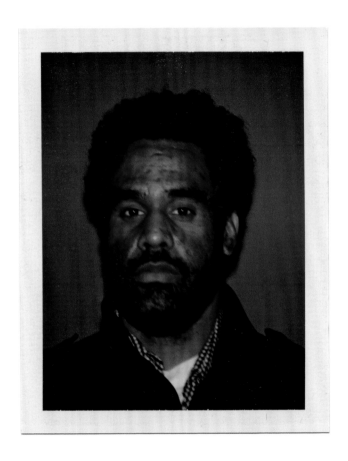

SACHA JENKINS

100

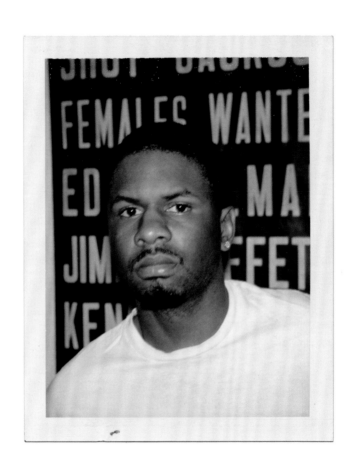

SHAE N*E*R*D

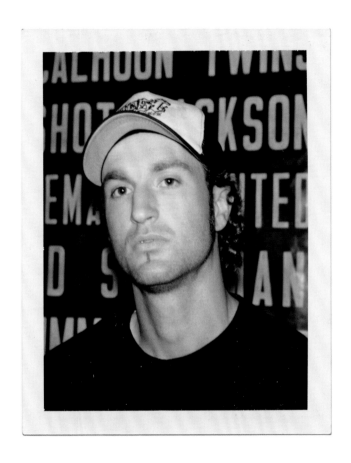

RONALD VENTURA - LEE HARVEY N*E*R*D

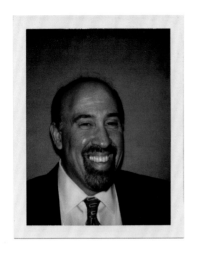

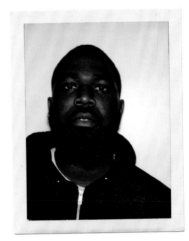

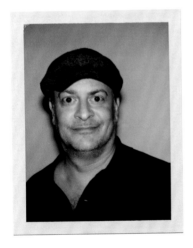

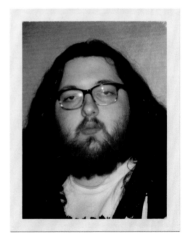

ROBERT GRUBMAN
ADAM SCHATZ

DILLA MAN
JOHN WAYNE

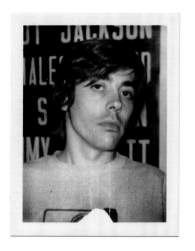
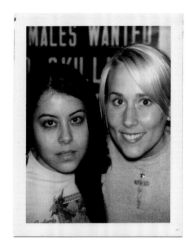
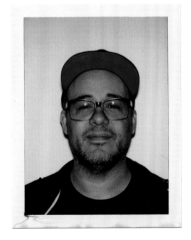
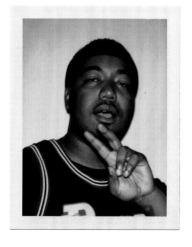

ARNAUD DELECOLLE JENNIFER DWIN & TAMMY BRAINARD
SHAHNTI O'NEILL DOMO GENESIS

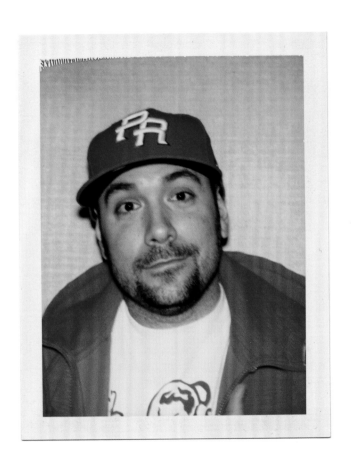

PETER ROSENBERG

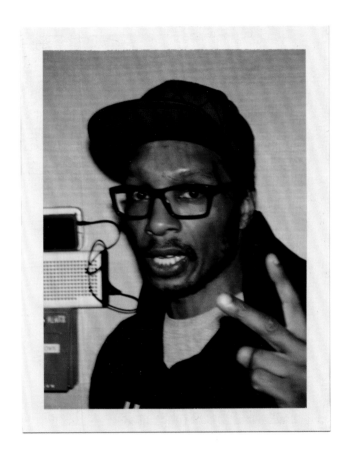

DEL THE FUNKY HOMOSAPIEN

106

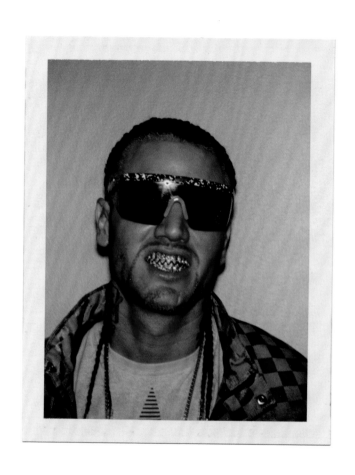

RIFF RAFF

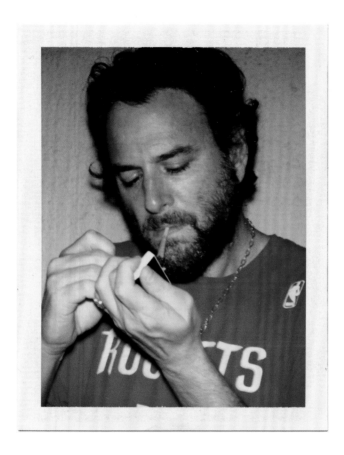

COLBY PARKER JR.

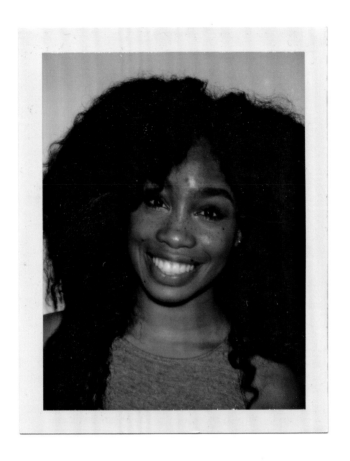

SZA

SCHOOLBOY Q

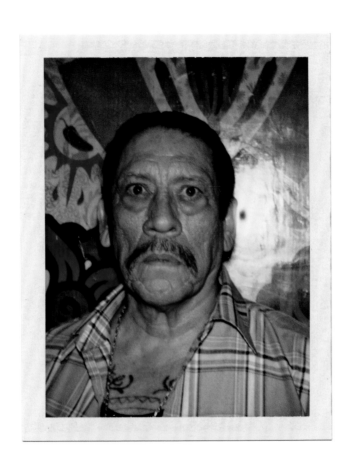

DANNY TREJO

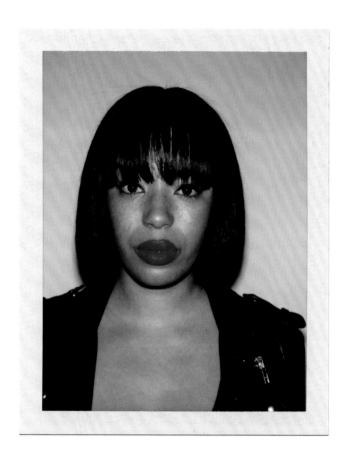

CAYLA COUSINS

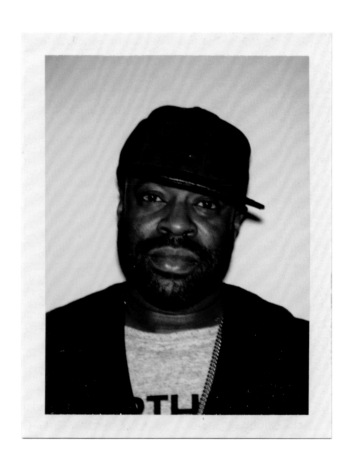

TARIQ TROTTER - BLACK THOUGHT

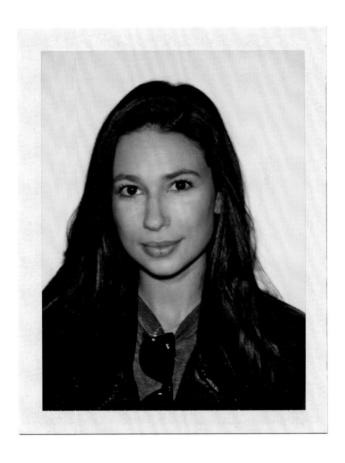

SARAH GOMES

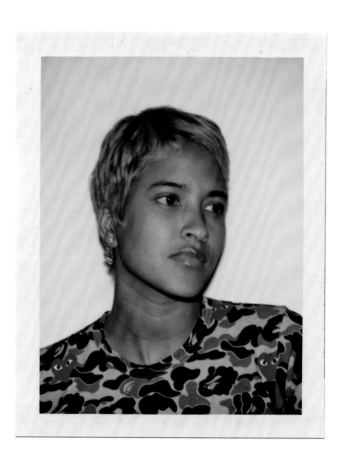

HELEN LASICHANH

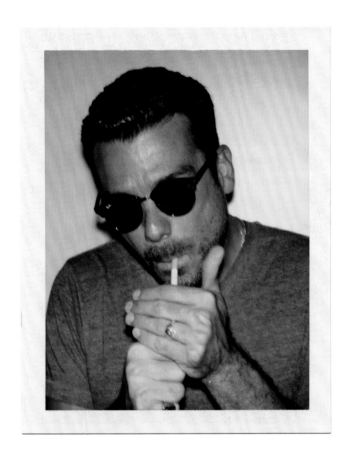

ANTONIO "NINO" SCALIA

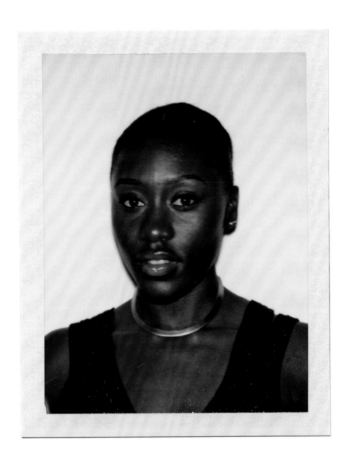

ZEYNA SY

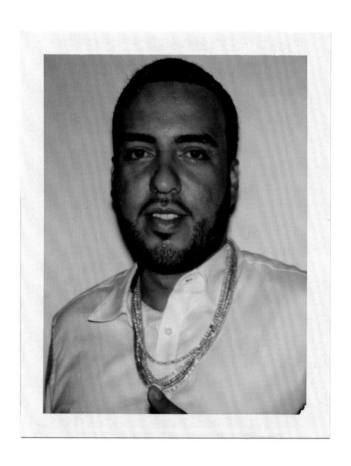

FRENCH MONTANA

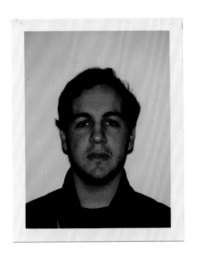 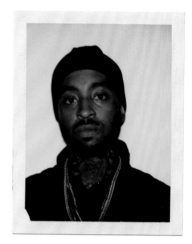

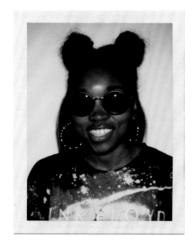 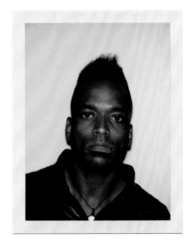

DEXTER NAVY SLEDGREN TAYLOR GANG
DJ DIAMOND KUTS CAPTAIN KIRK DOUGLAS

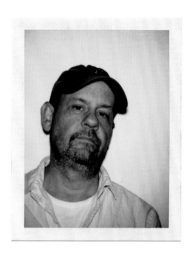
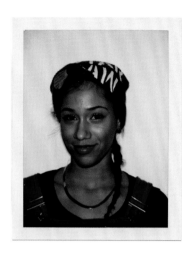
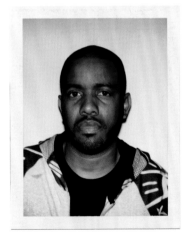
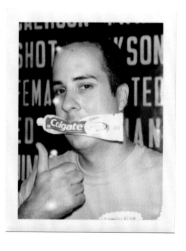

GREG LaMARCHE
TUBA GOODING JR.

BIA
STEVE "ESPO" POWERS

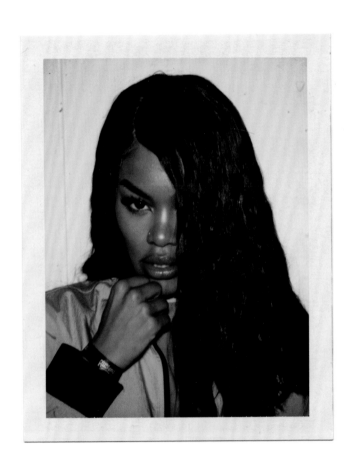

TEYANA TAYLOR

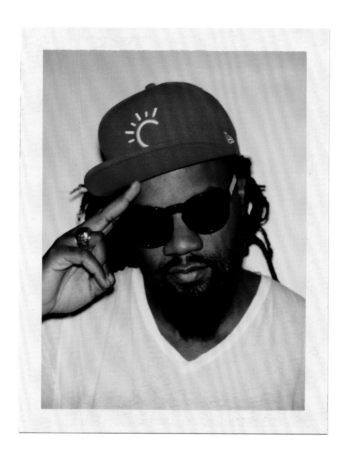

COLTRANE CURTIS

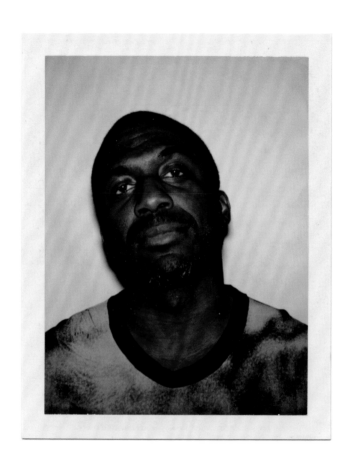

COREY SMYTH

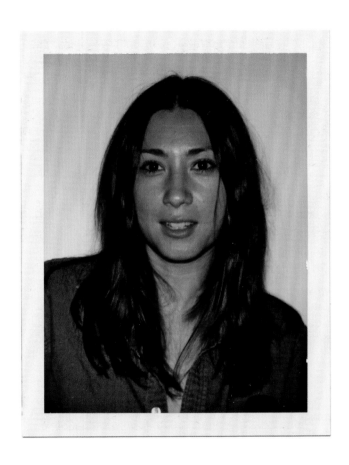

JENN BRILL

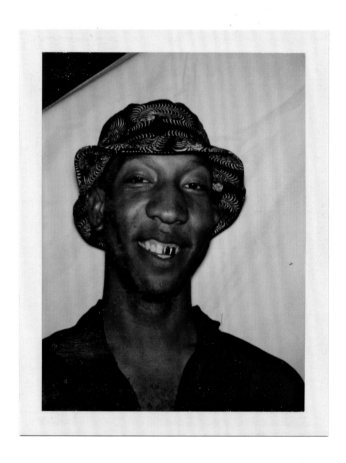

LEFT BRAIN

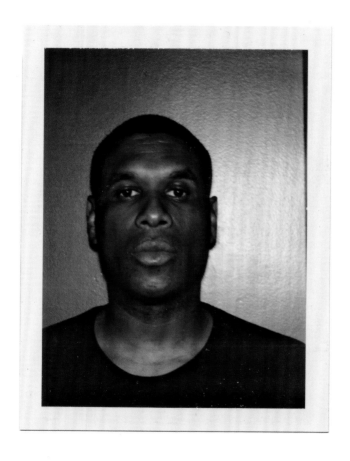

JAY ELECTRONICA

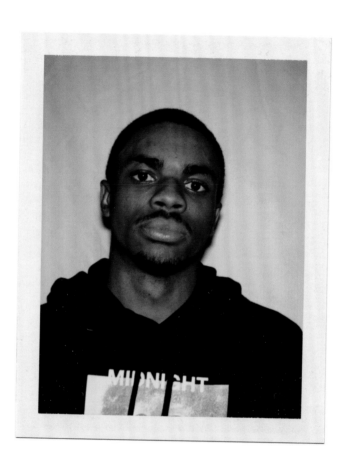

VINCE STAPLES

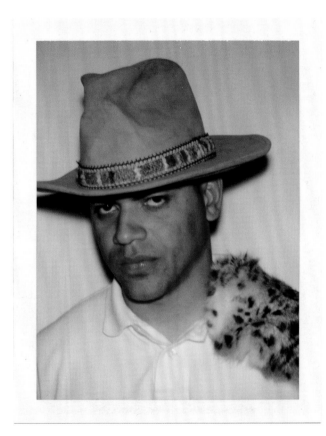

JOHNNY CAKES

128

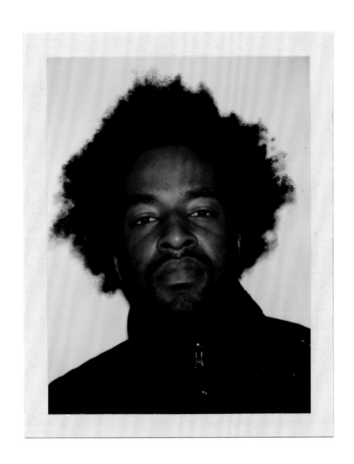

JELANI DAY

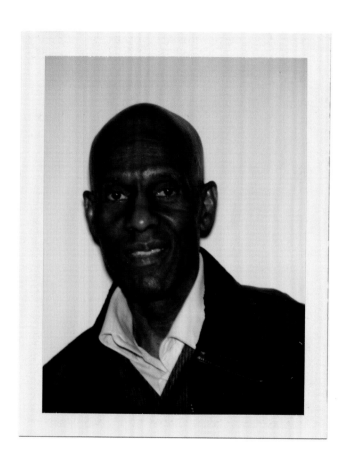

DAPPER DAN of HARLEM

130

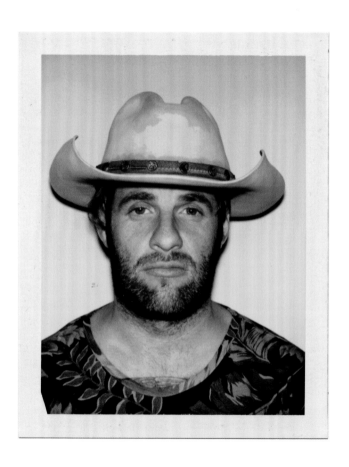

CHRIS FOLKERTS

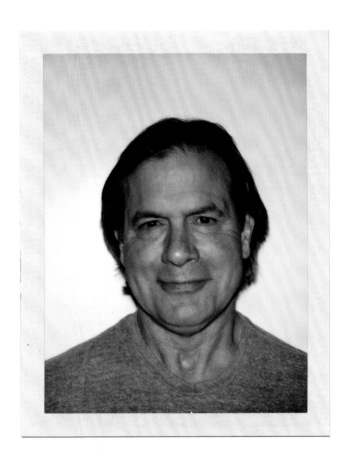

JAKE BURTON

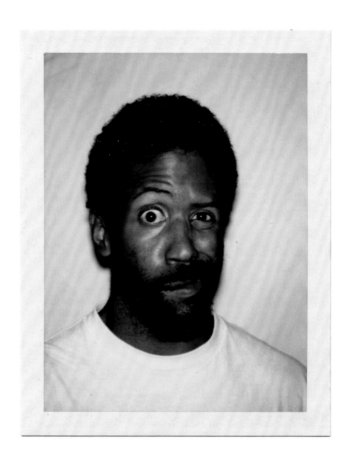

MURS

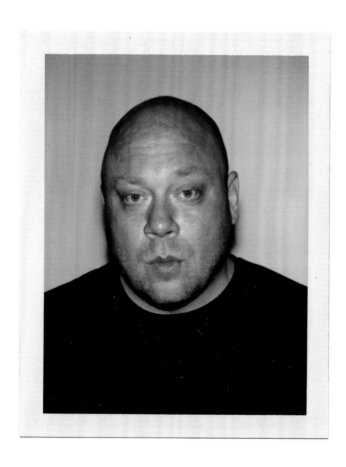

PHIL FROST

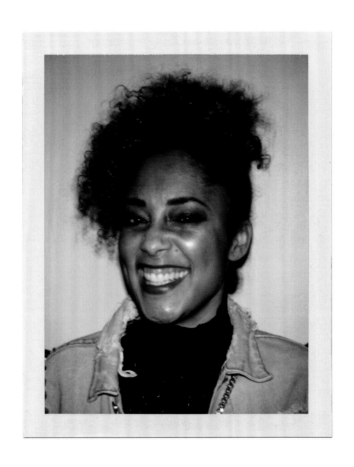

AMANDA SEALES

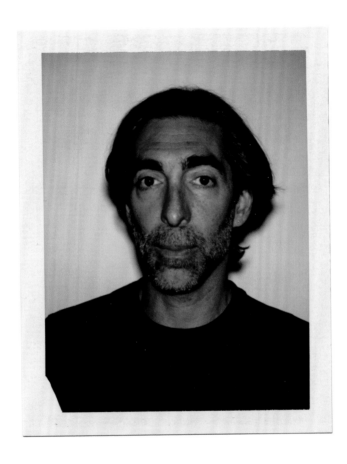

MARC LaBELLE

136

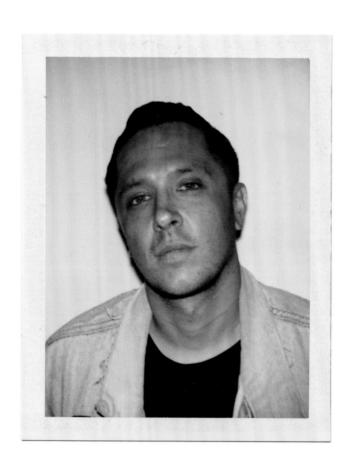

SPANTO - BORN x RAISED - VENICE13

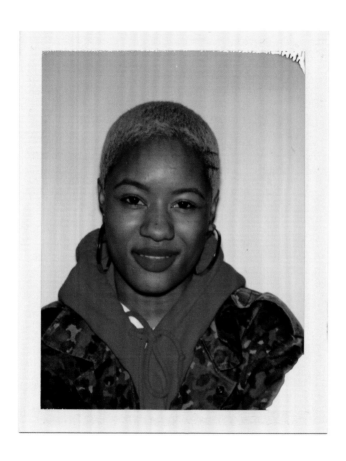

KAYA MARLEY

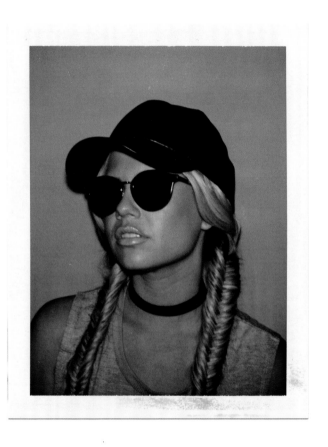

CHANEL WESTCOAST

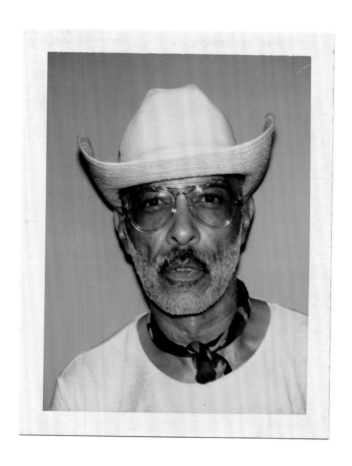

LONO BRAZIL

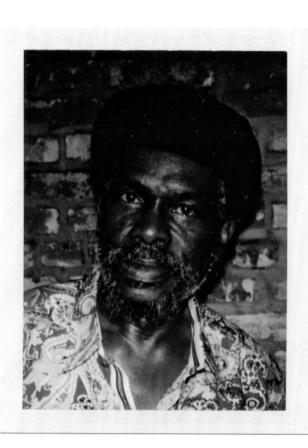

JOHNNY OSBOURNE

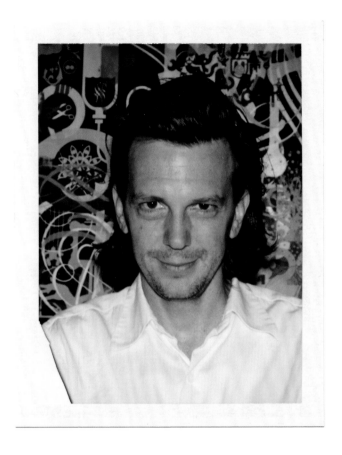

RYAN MᶜGINNESS

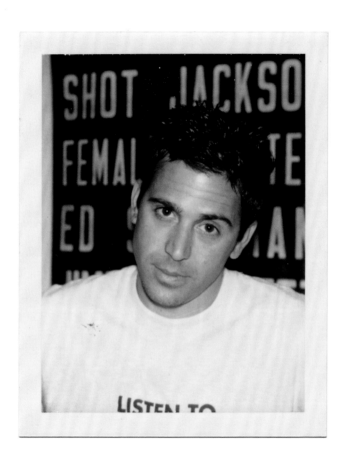

JASON NOTO

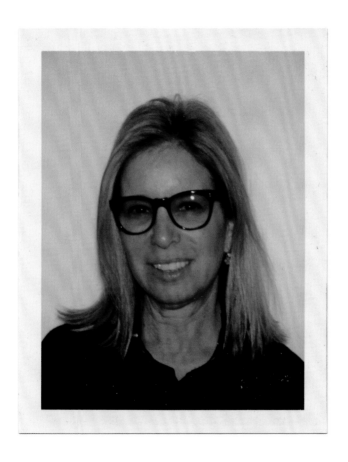

RONNIE COOKE NEWHOUSE

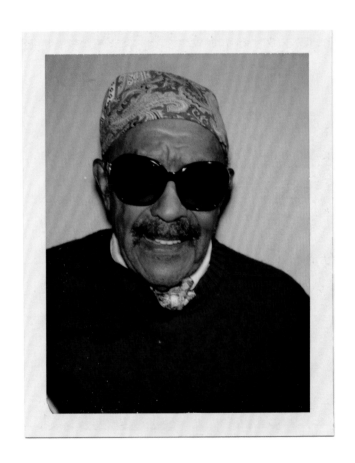

THEODORE DIXON

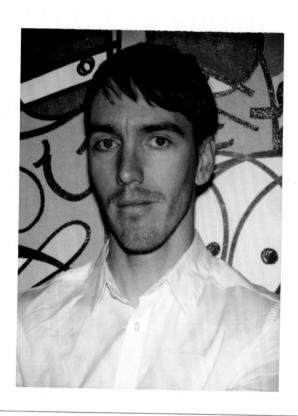

TIMOTHY CURTIS - AGUA

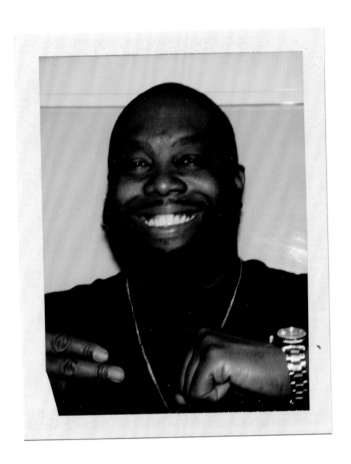

KILLER MIKE

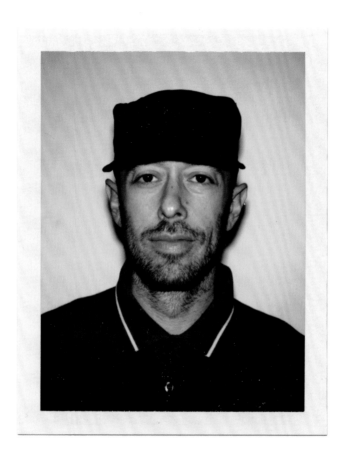

MAX GLAZER

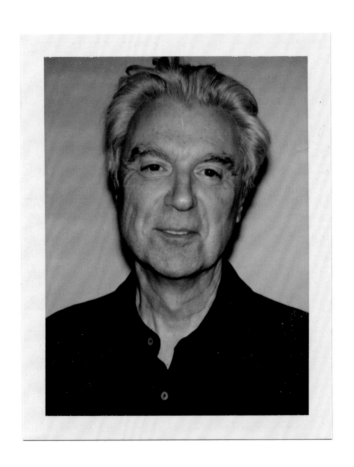

DAVID BYRNE

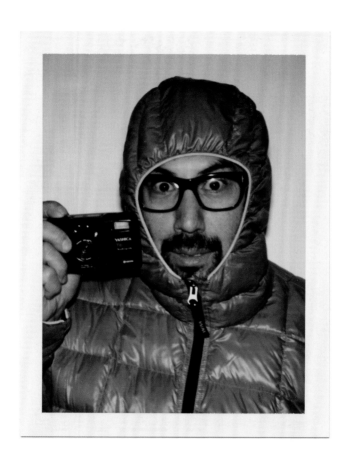

DAVID "SHADI" PEREZ

150

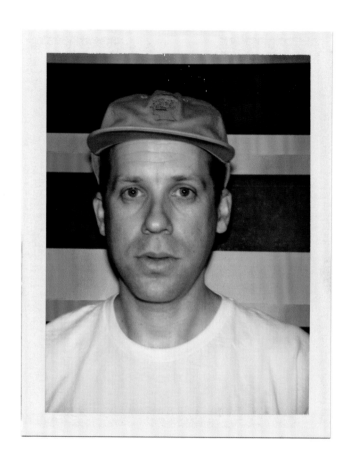

ERIC ELMS

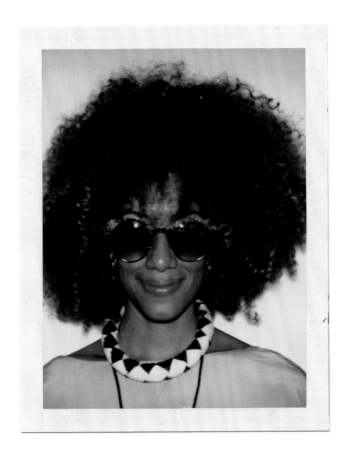

LUNA

152

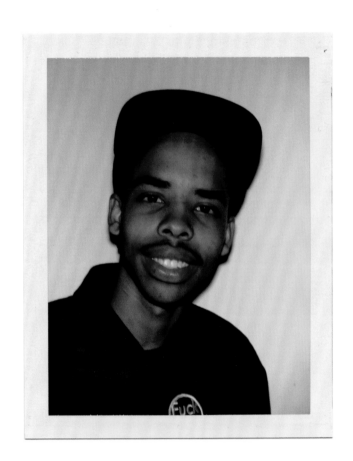

EARL SWEATSHIRT

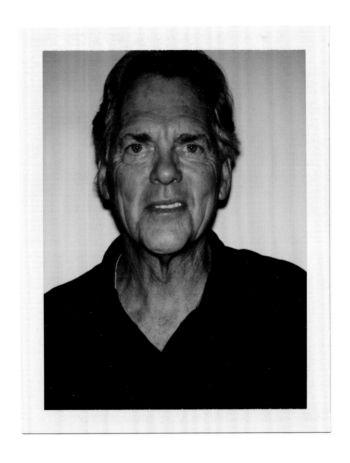

CHIP QUIGLEY

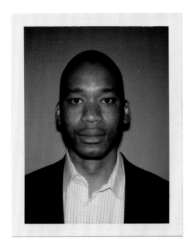
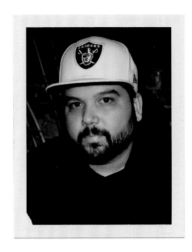
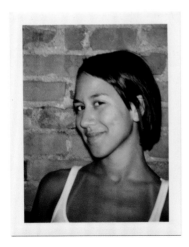
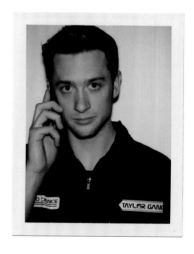

TYSON TOUSSANT
MARCELLA LEEDS

DJ SOUL
WILL DZOMBAK

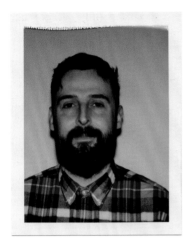

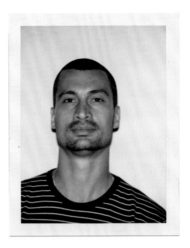

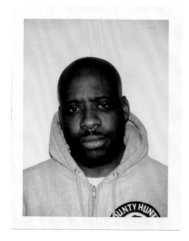

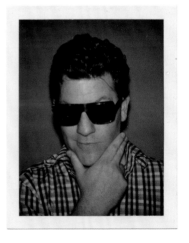

HARLEY ADDISON
SET FREE

SKY GELLATLY
IAN DOYLE

156

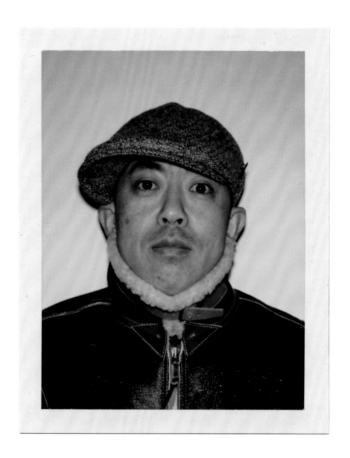

NIGO®

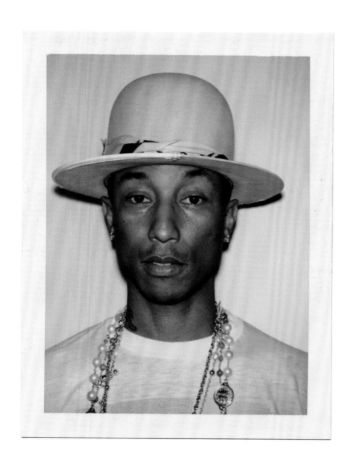

PHARRELL WILLIAMS

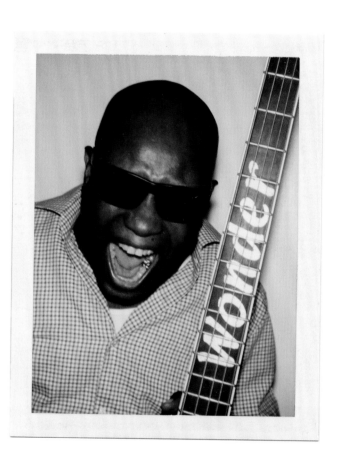

JERRY WONDER

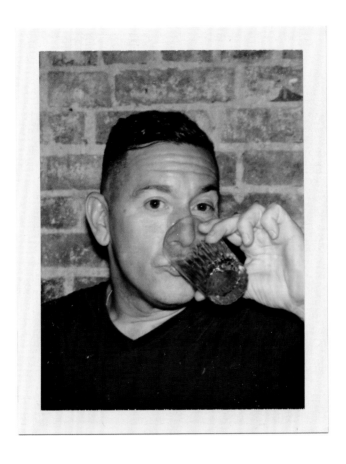

ROB JEST

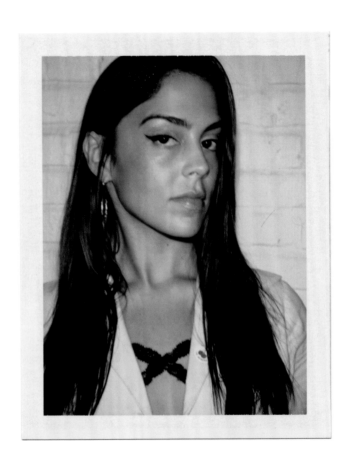

TABATHA MᶜGURR

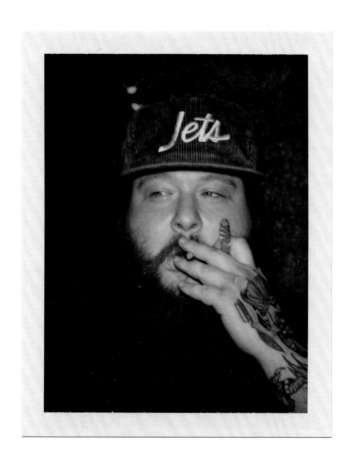

ACTION BRONSON

162

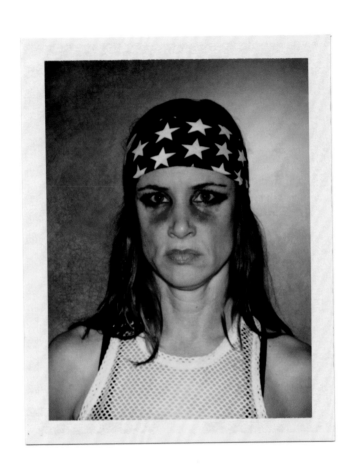

JULIETTE LEWIS

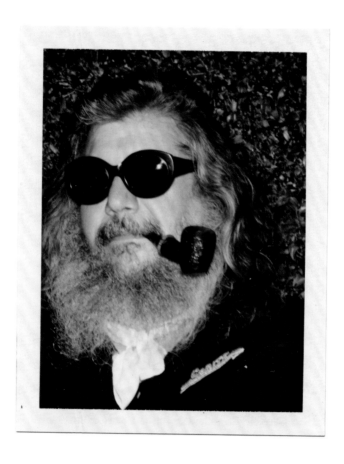

GEORGE DRAKOULIAS

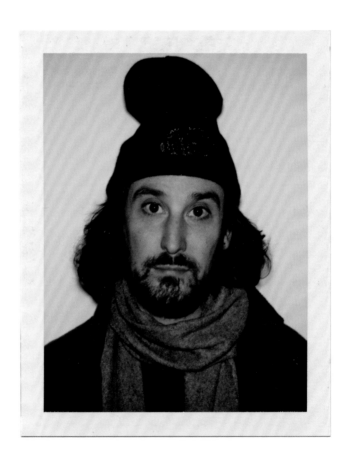

MISTER MORT

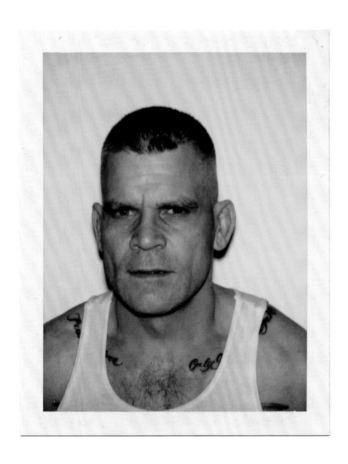

HARLEY FLANAGAN

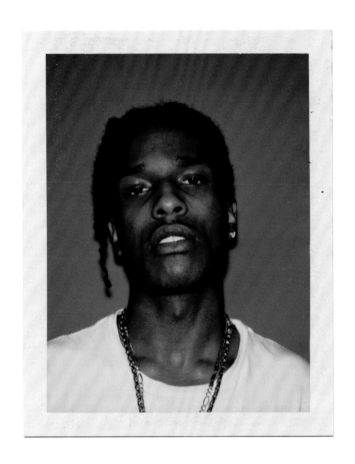

A.$.A.P. ROCKY

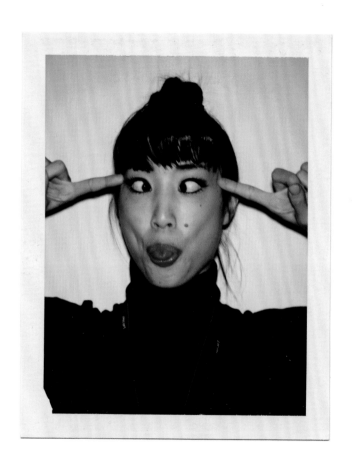

AI SHIMATSU

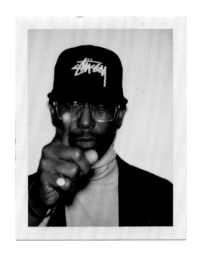

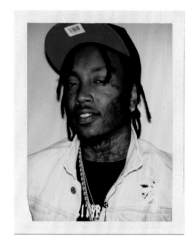

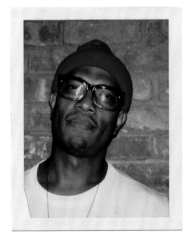

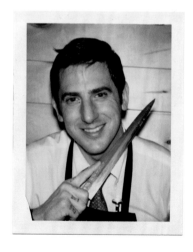

ANDRE PINARD BRICC BABY

ADRIAN MILES JOHN DALEY

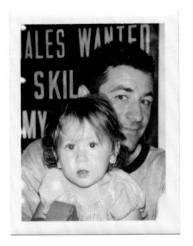
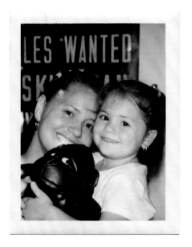
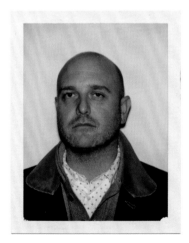
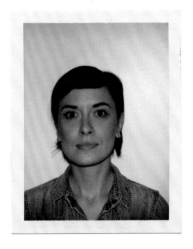

DEAN & GIA COPPOLA RENE & GEMMA COPPOLA

STUART GRAHAM ALMA LACOUR

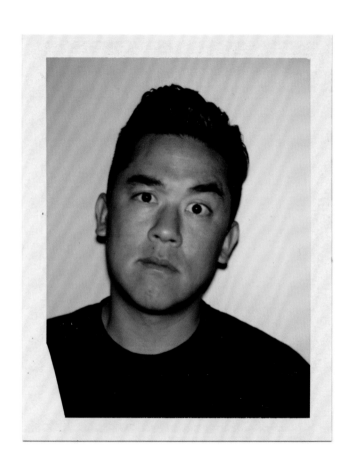

BOBBY HUNDREDS

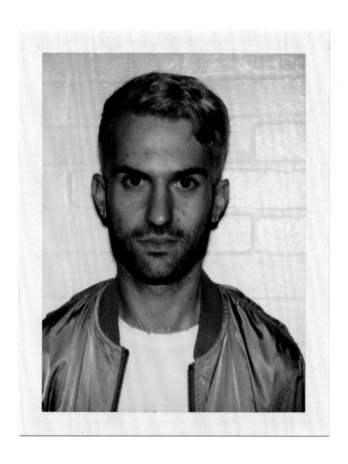

A-TRAK

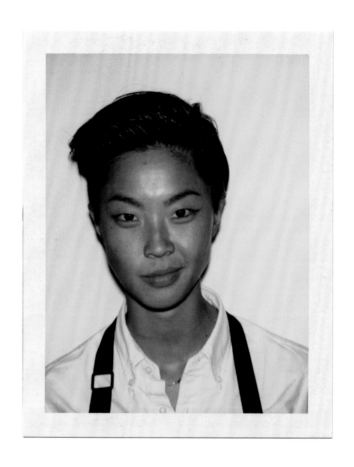

KRISTEN KISH

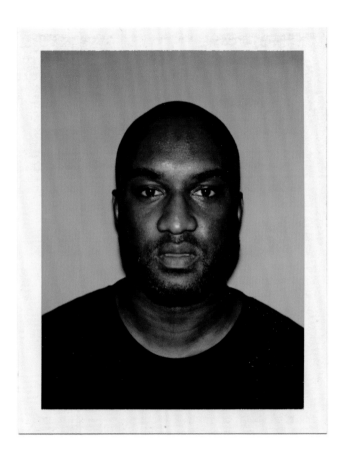

VIRGIL ABLOH

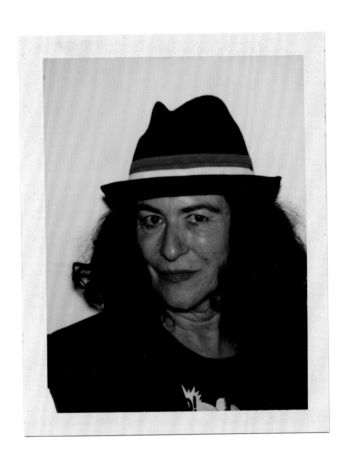

JANETTE BECKMAN

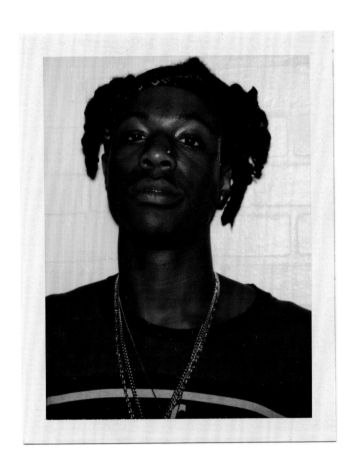

JOEY BADA$$

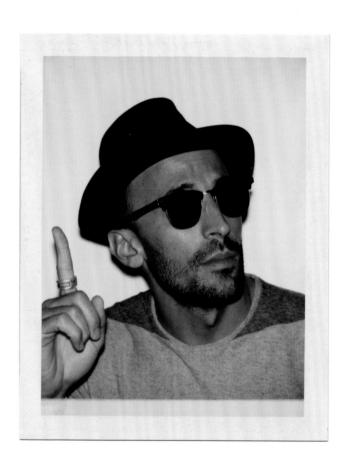

JR

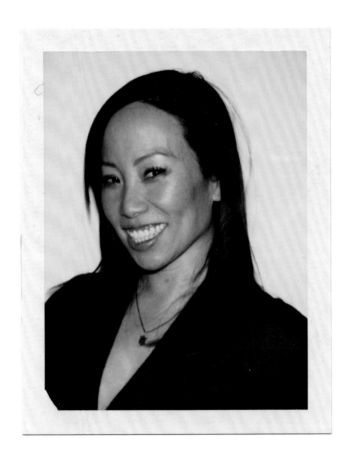

MINYA OH - MISS INFO

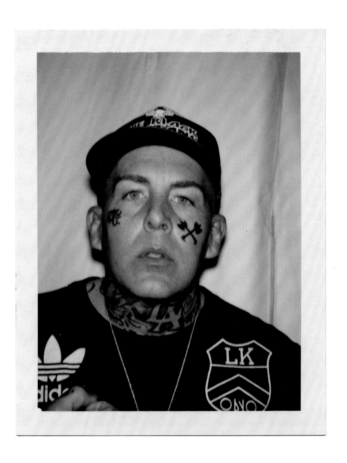

MADCHILD

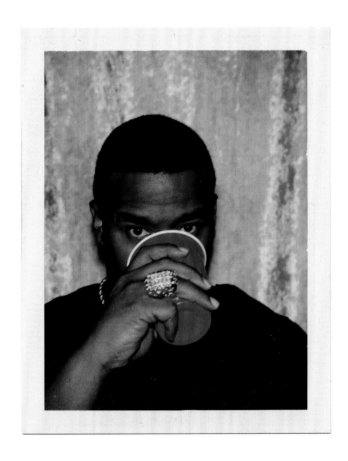

KAWAN "KP" PRATHER

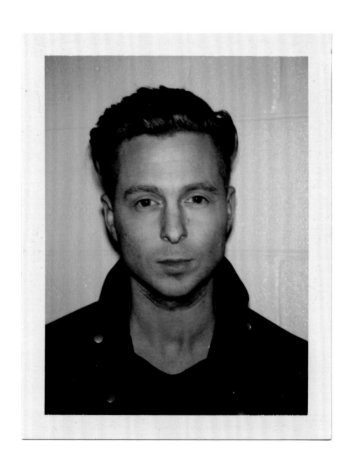

RYAN TANNER

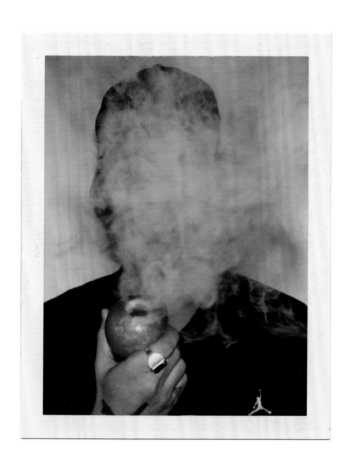

SCOOP DeVILLE

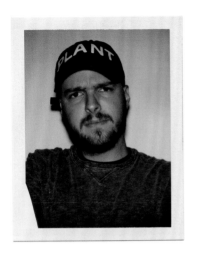

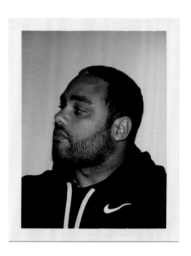

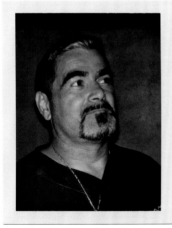

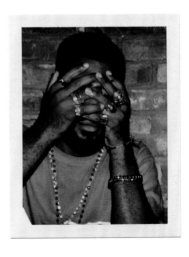

KEVIN McMULLAN

KAMAL GRAY

ROBERT "FROG" MENDOZA

MARK ANTHONY GREEN

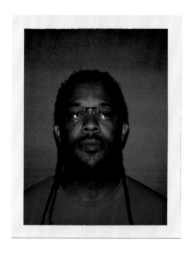

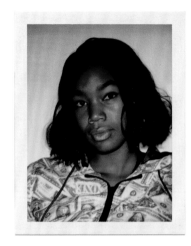

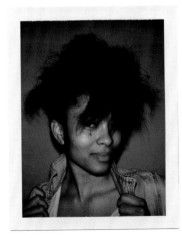

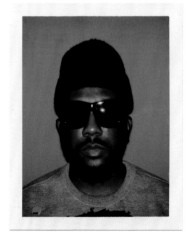

ERIC BLAMOVILLE SYMONE MABRY

JAVANA MUNDY FERRIS BUELLER

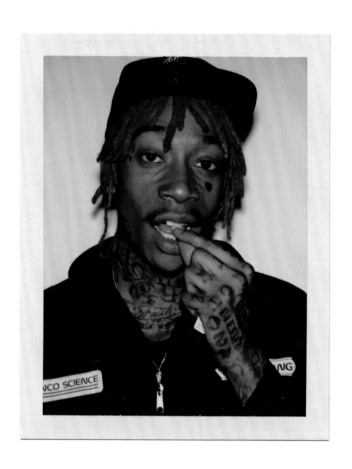

WIZ KHALIFA

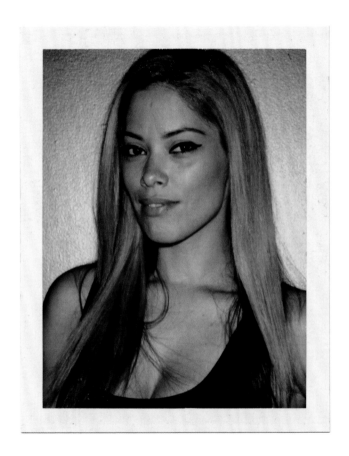

SELINA COLON

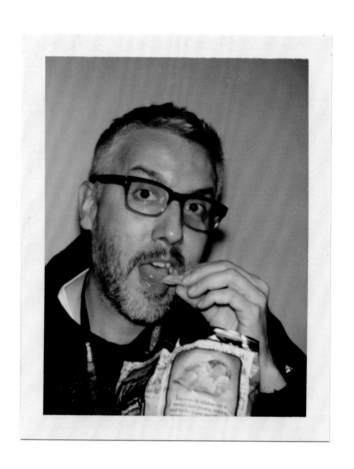

LOIC VILLEPONTOUX

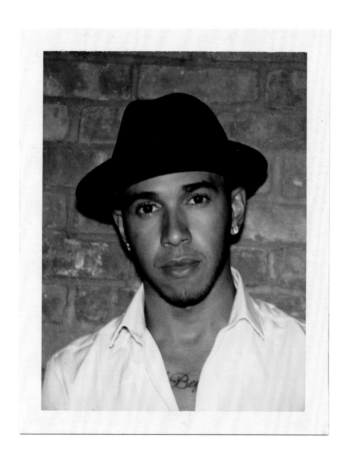

LEWIS HAMILTON

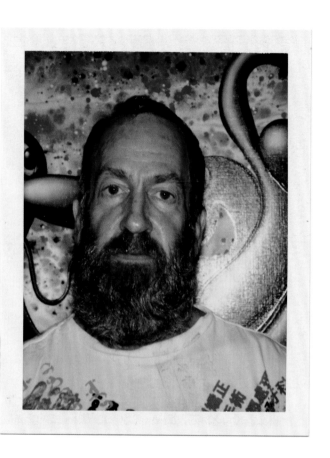

KENNY SCHARF

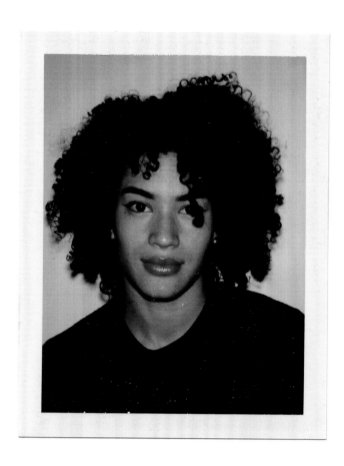

METTE TOWLEY

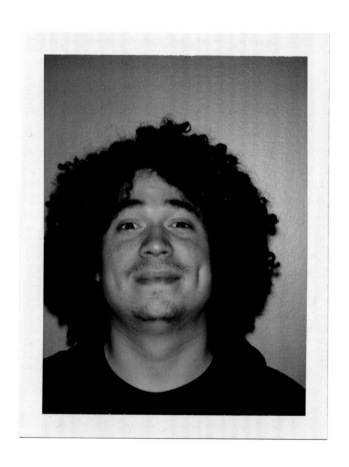

MIKE LARSON

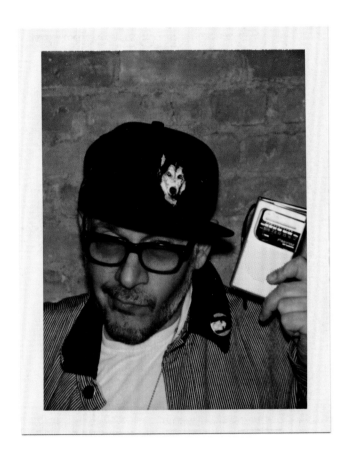

RICKY POWELL

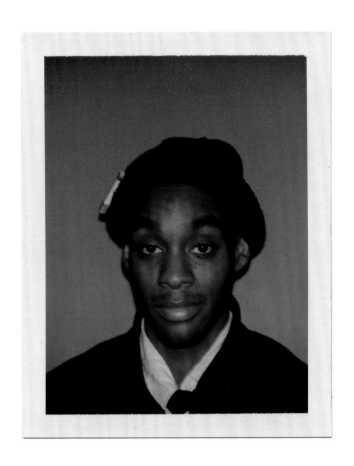

RICARDO JACKSON

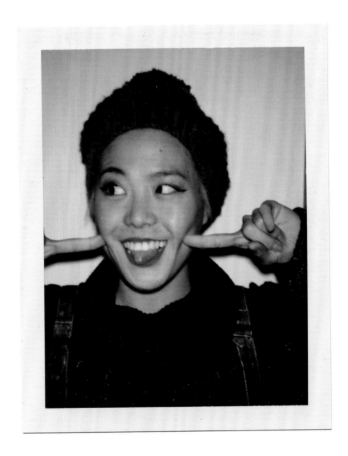

AYE HASEGAWA

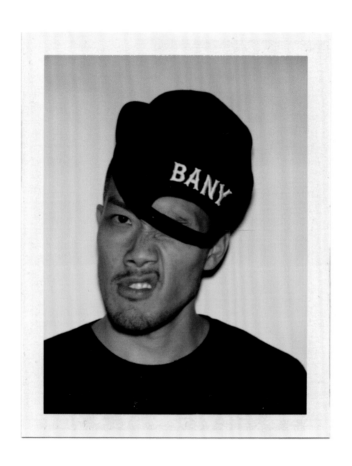

DAO-YI CHOW

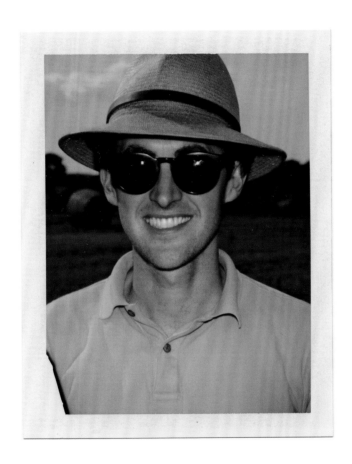

PETER MILLER

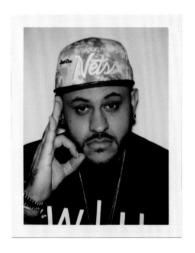
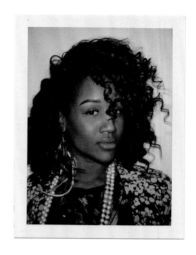
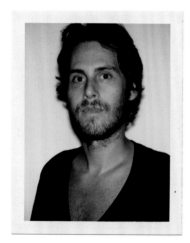
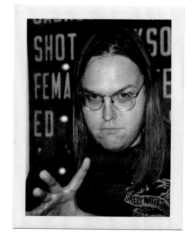

MICHAEL CAMARGO - UPSCALE VANDAL BRYA UNDERWOOD

ZACHARY ZELDIN BEN SMITH

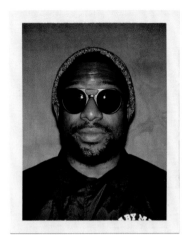

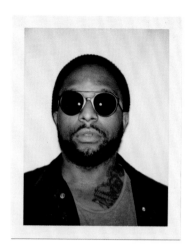

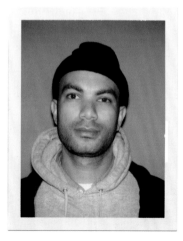

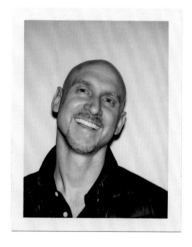

KEHINDE HASSAN

TREIS HILL

TAIWO HASSAN

BRENT PASCHKE

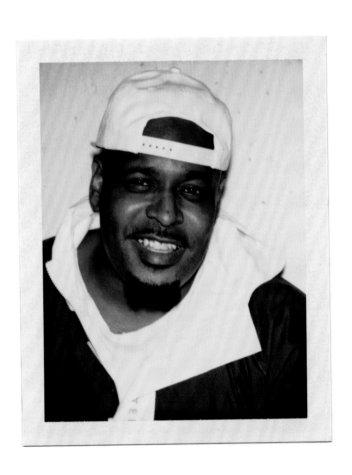

SHEEK LOUCH

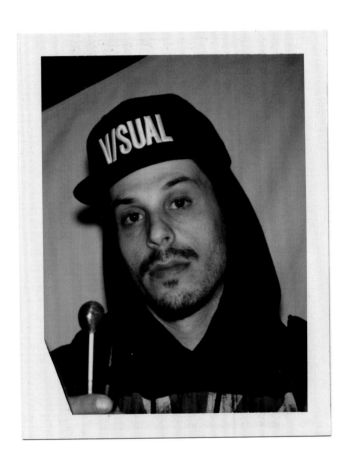

EVIDENCE

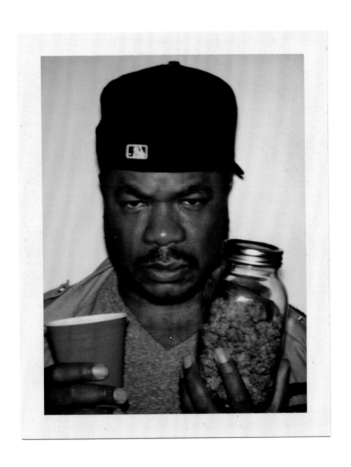

XZIBIT

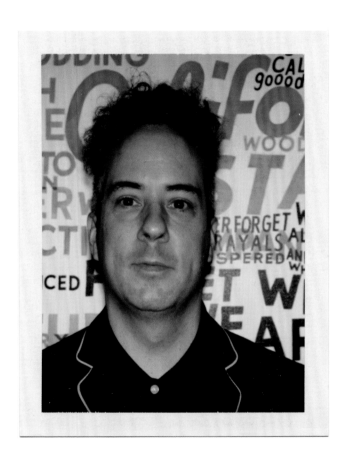

STEVE "ESPO" POWERS

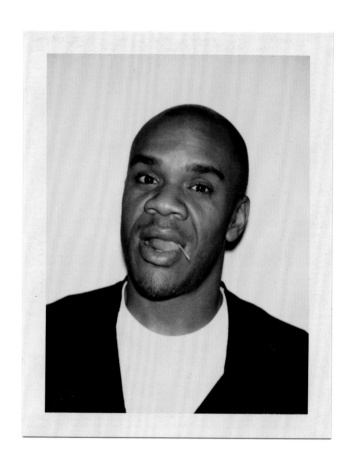

202

BAHR BROWN

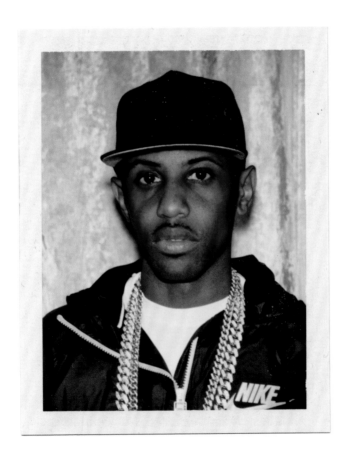

FABOLOUS

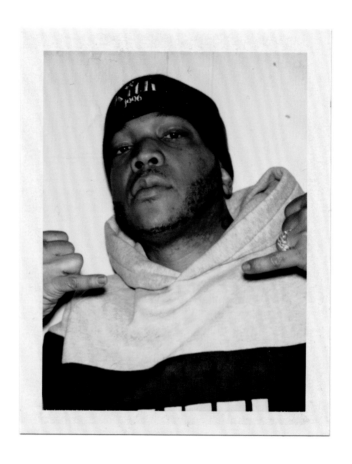

STYLES P

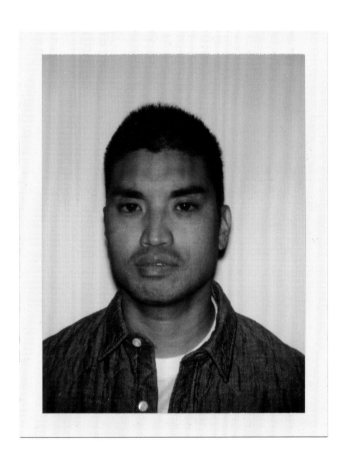

CHAD HUGO

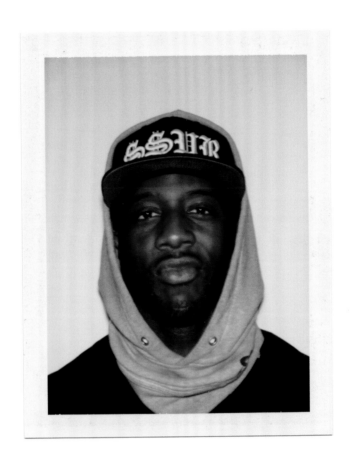

NIGEL SYLVESTER

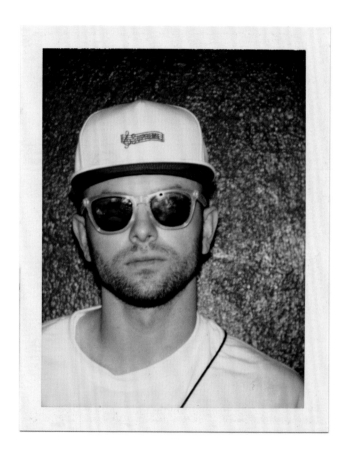

BRICK STOWELL

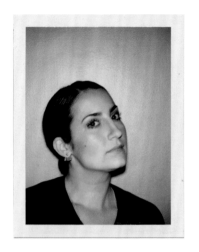

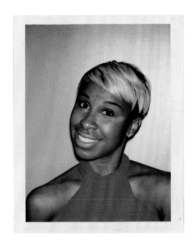

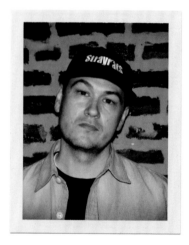

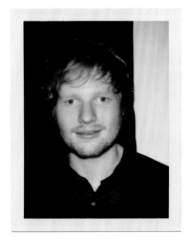

ALEXANDRA DePERSIA

PLAIN PAT

APRIL McDANIELS

ED SHEERAN

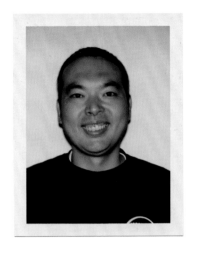
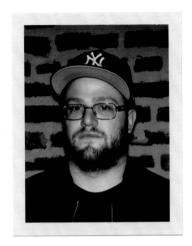
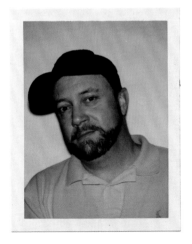
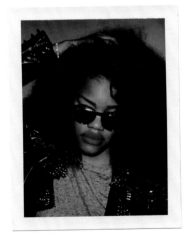

MISTER ZONE

BEN SOLOMON

DREW COLEMAN

TEYANA TAYLOR

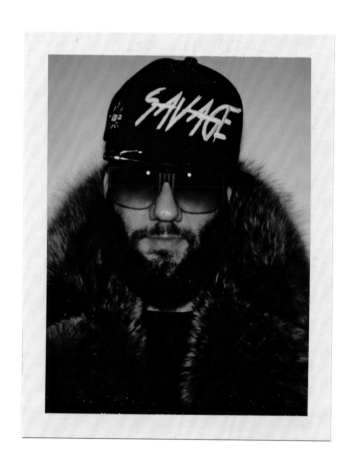

COREY SHAPIRO

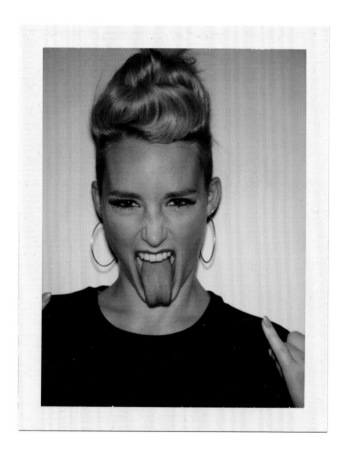

CHRISTINA CHANDLER

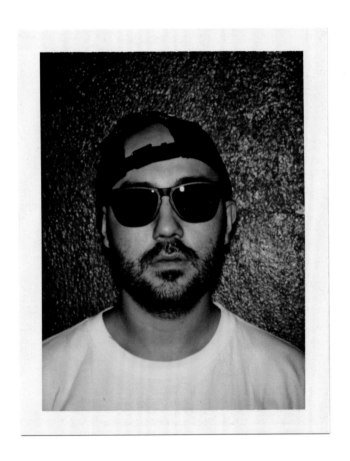

13TH WITNESS

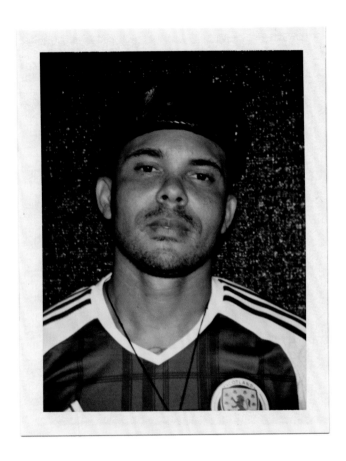

213

WALSHY FIRE

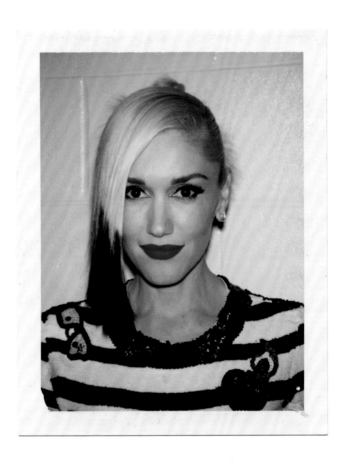

GWEN STEFANI

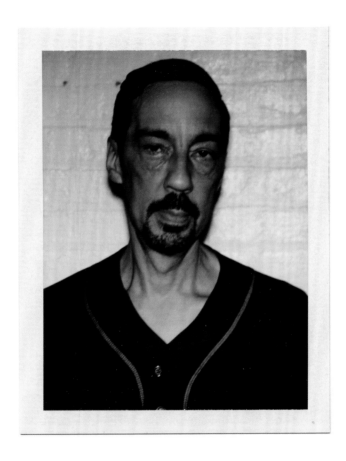

FUTURA

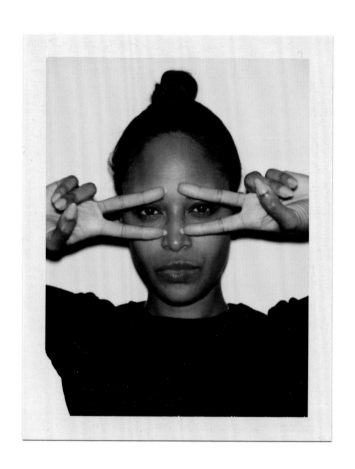

JACKIE HOLLAND

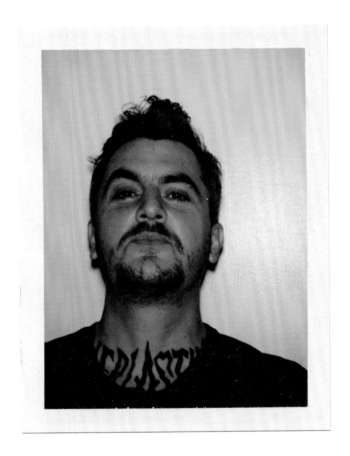

JASON GOLDWATCH

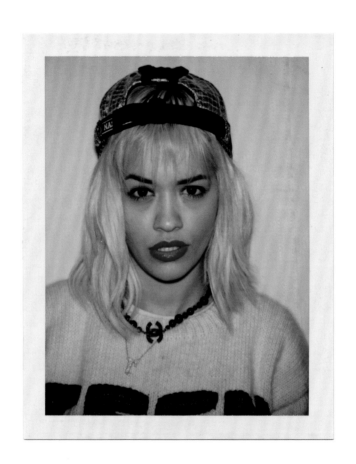

RITA ORA

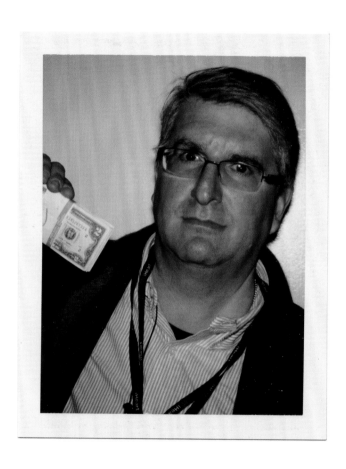

TWO DOLLAR STEVE

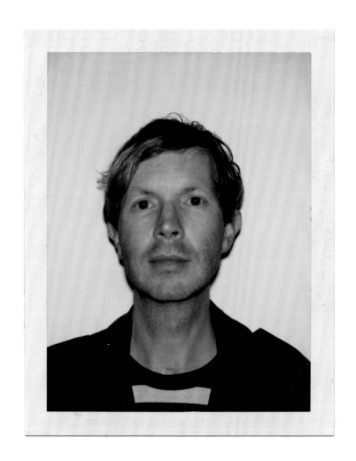

BECK

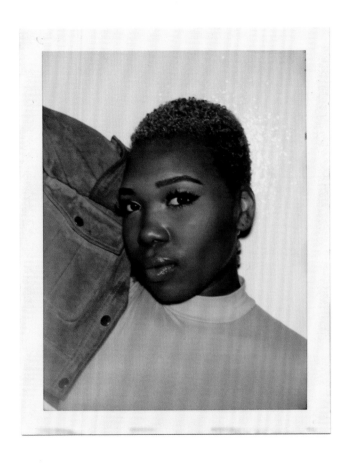

DANASIA SUTTON

222

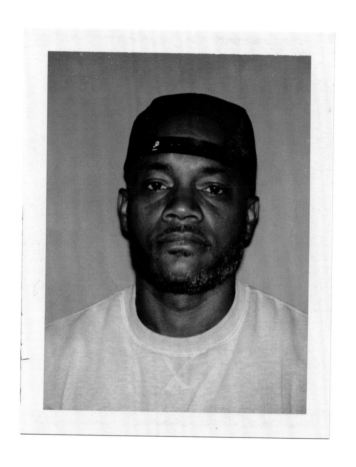

SEAN C

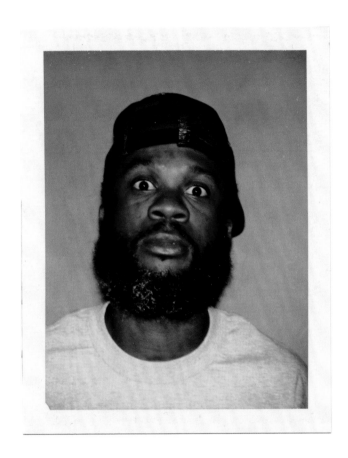

223

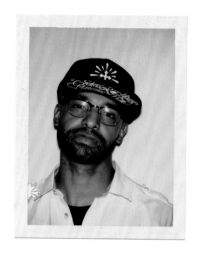
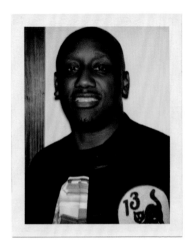

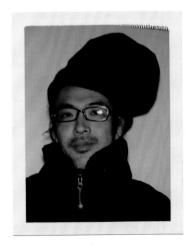

COREY EDNESS
RUFFY LEEDS

CHAKA ZULU
TAK

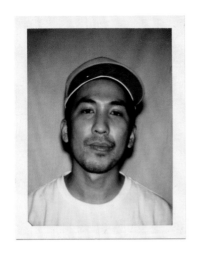
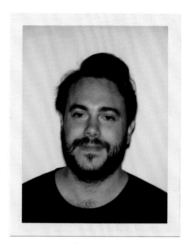
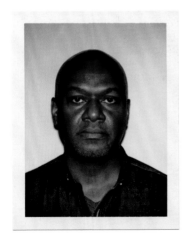
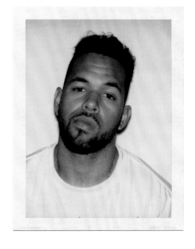

ALEXANDER SPIT KALEN HOLLOMON
JAMES POYSER JORDAN PAYTON

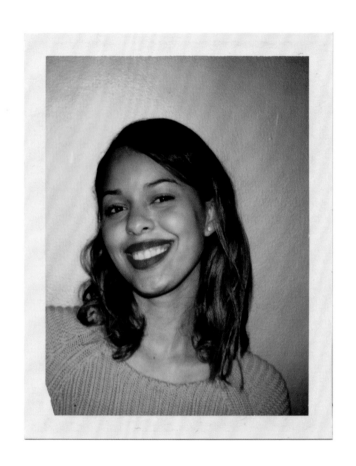

DOMINIQUE MALDONADO

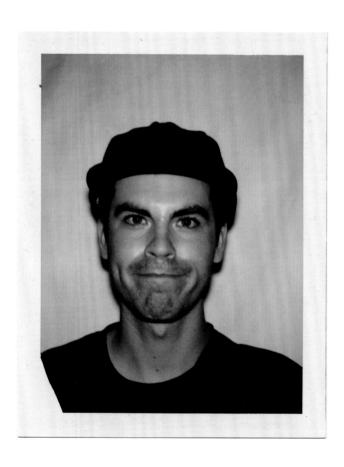

SAGAN LOCKHART

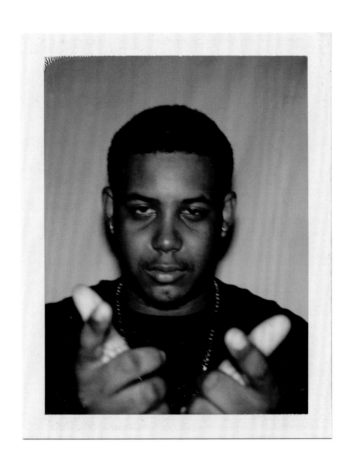

NASTY BOY JASPER

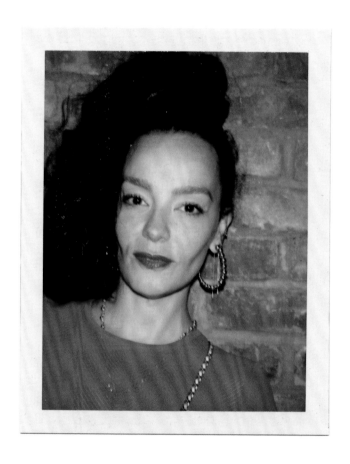

$HERRY COSOVIC

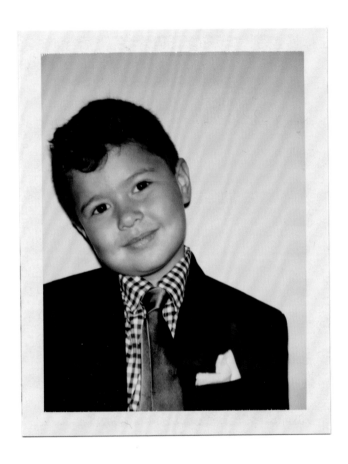

THEODORE LEEDS

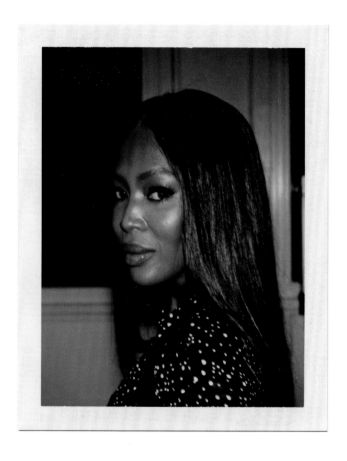

NAOMI CAMPBELL

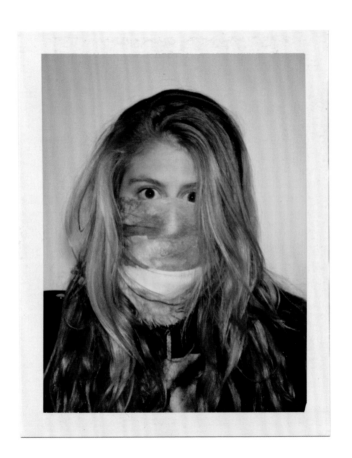

AUSTYN WEINER

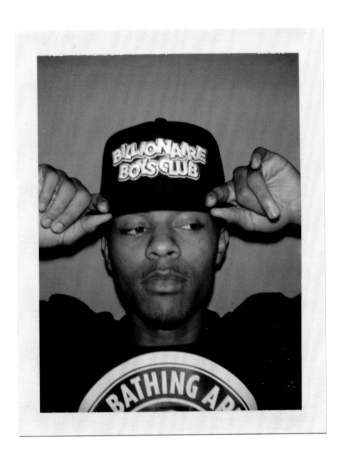

BOW WOW

234

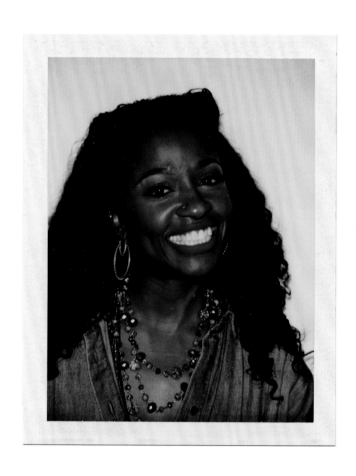

TANISHA SCOTT

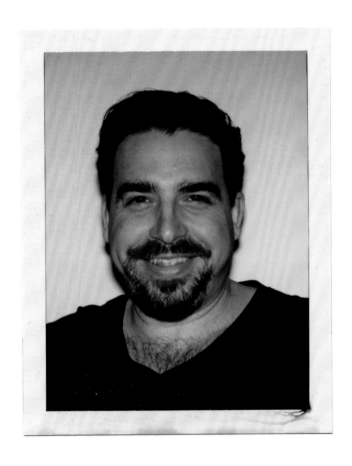

JASON PINSKY

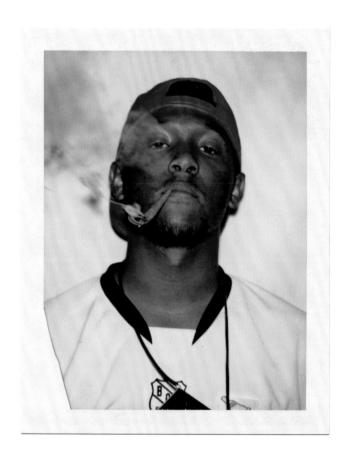

HIT BOY

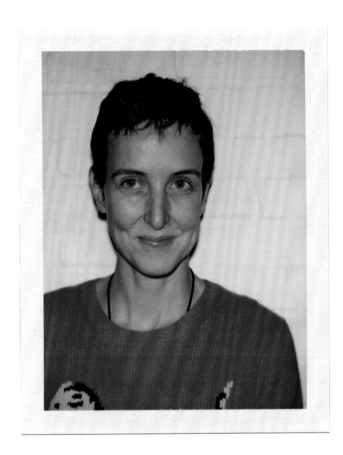

SARAH COLETTE

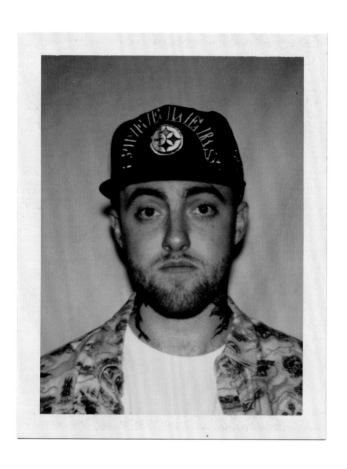

MAC MILLER

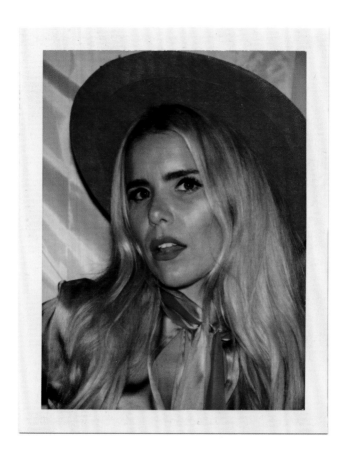

PALOMA FAITH

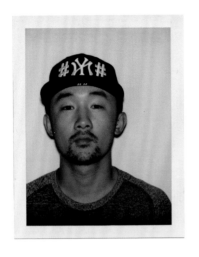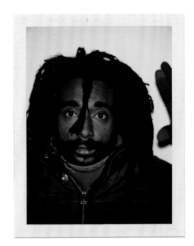

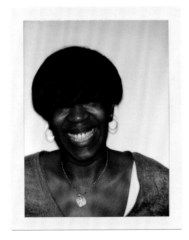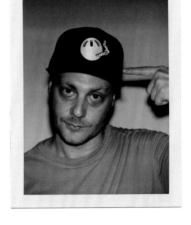

ROCKY XU EVIE NO-MADDZ

MICELLE CARTER BT ROCKWELL

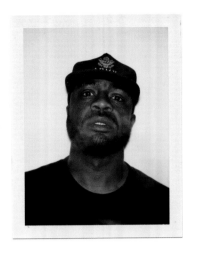

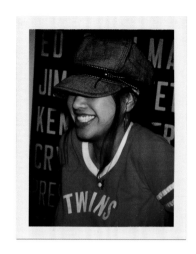

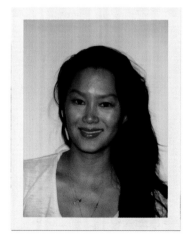

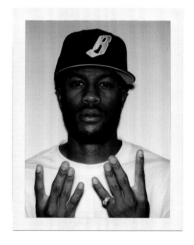

KYAMBO "HIP HOP" JOHNSON

BEA TALPLACIDO

LISA CHU

CASEY VEGGIES

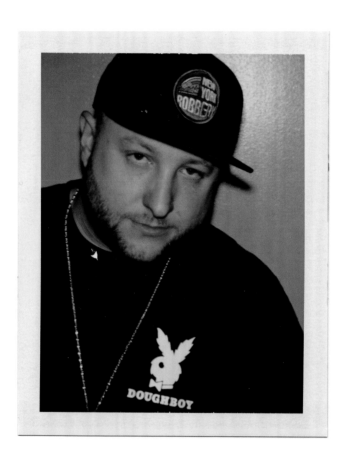

STATIK SELEKTAH

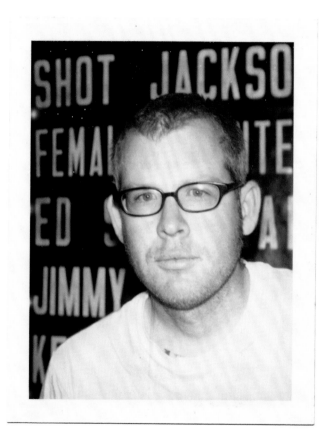

243

MIKE GIANT

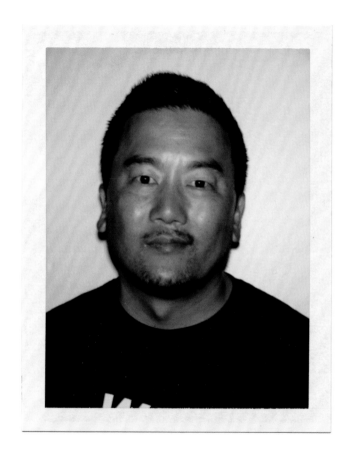

ROY CHOI

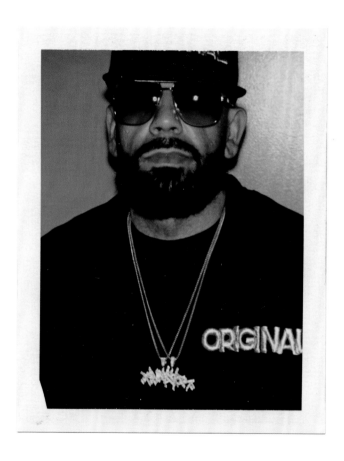

MAYOR

246

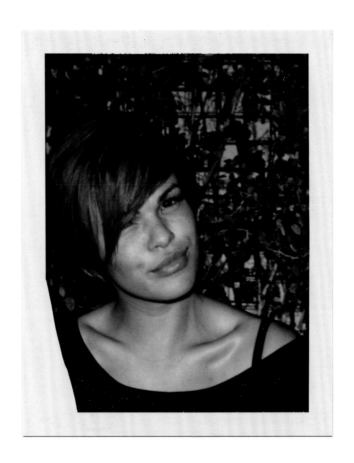

EMILY ROSE

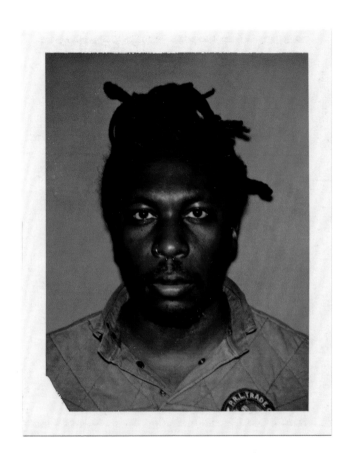

88 KEYS

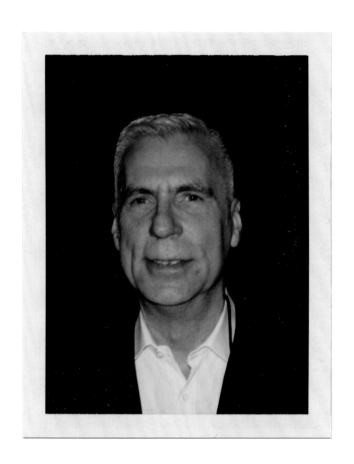

JOHN GIDDINGS

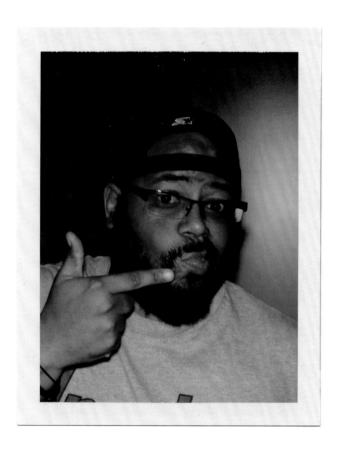

MR. LEN - COMPANY FLOW

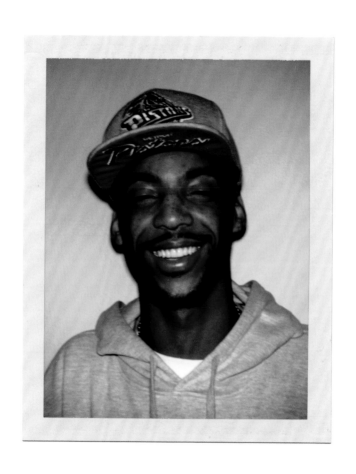

BOLDY JAMES

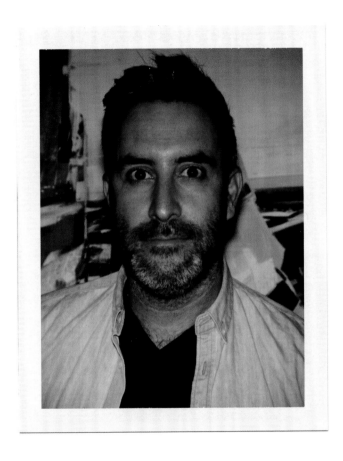

MICHAEL KAGAN

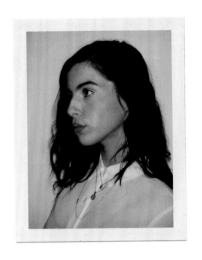
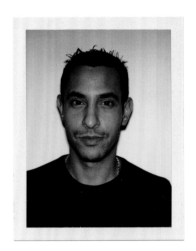
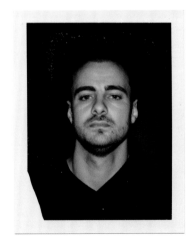
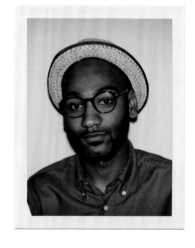

SIOBHAN BOYLE BEN YEFET
BRANDON ROSENBLATT HILTON "DEUCE" WRIGHT

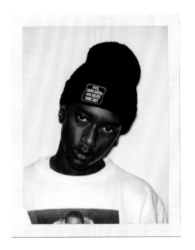
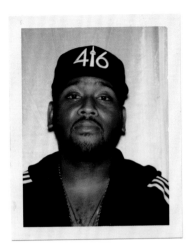
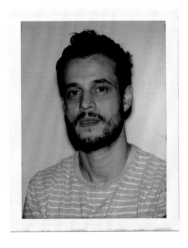
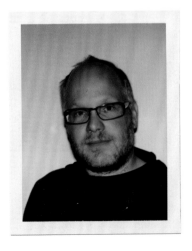

BUDDY
DIEGO MOSCOSO

BOI 1DA
JOE BMW

254

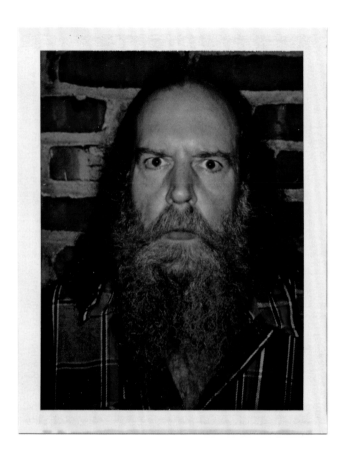

MIKE SCHNAPP

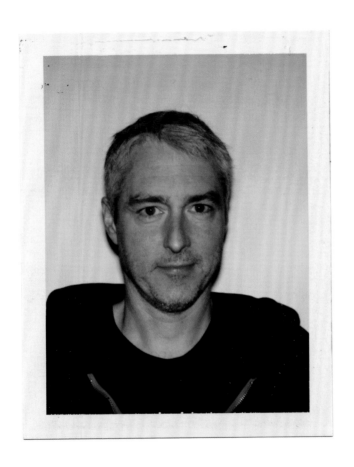

"AJ" SOUR DIESEL

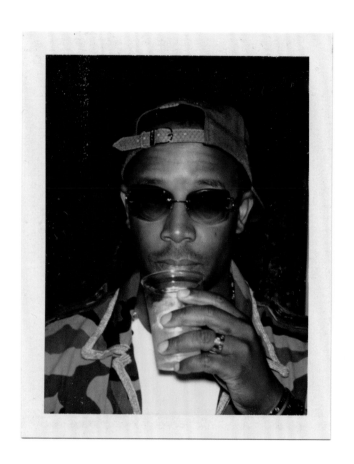

BRENNAN RABB

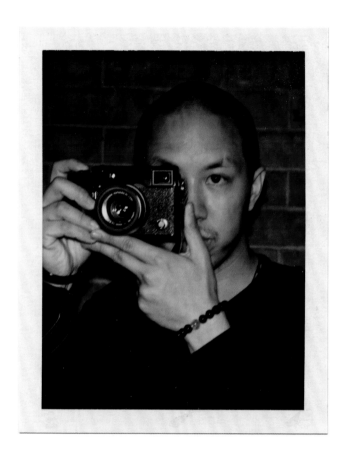

WILLIAM YAN

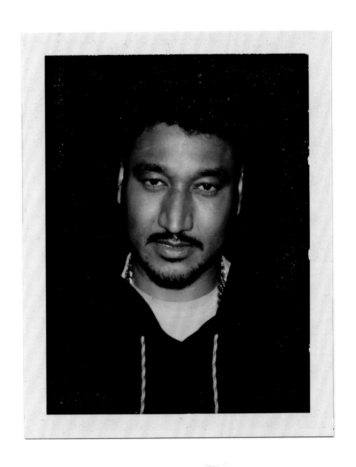

DON C

DICE THE GOD

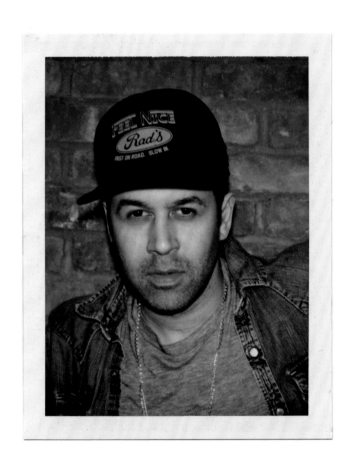

JUS SKE

HAWAII MIKE

KRONDON

LATRELLE "MUNCHIE" SIMMONS

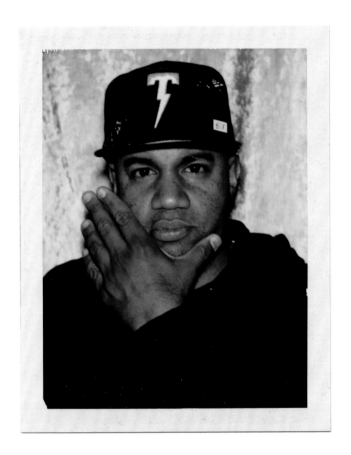

LENNY S

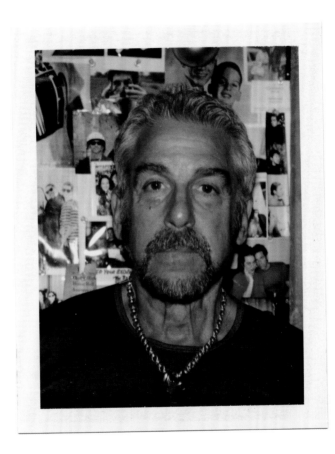

MARC BALET

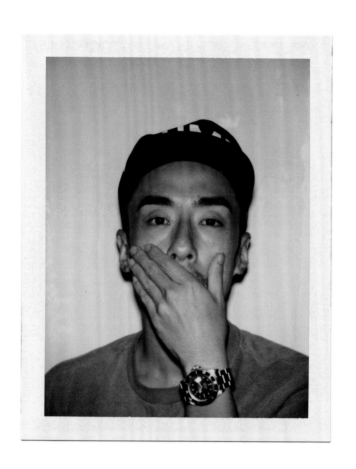

KEVIN POON

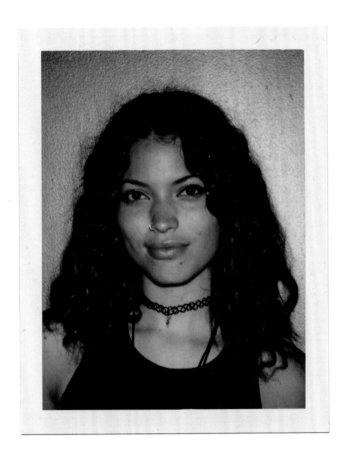

MAXINE ASHLEY

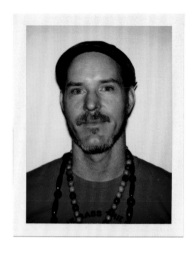
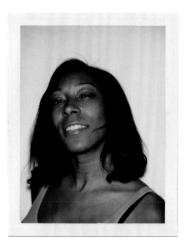
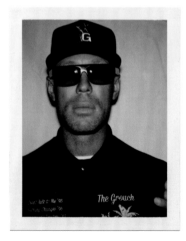
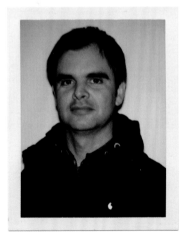

JOHN EMCH LOLA COLEMAN

THE GROUCH JAMES MAY

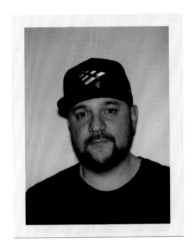

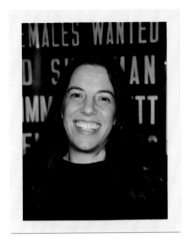

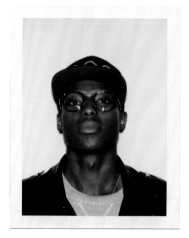

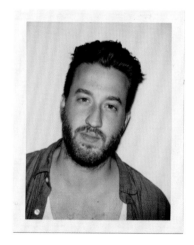

DENIS IDERMAN

LESLIE GREENE

REGINALD SYLVESTER II

RYAN POTESTA

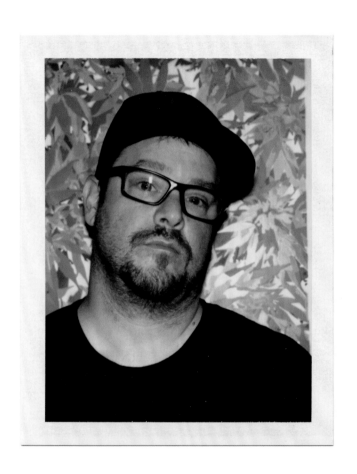

JOSH FRANKLIN - MR. STASH

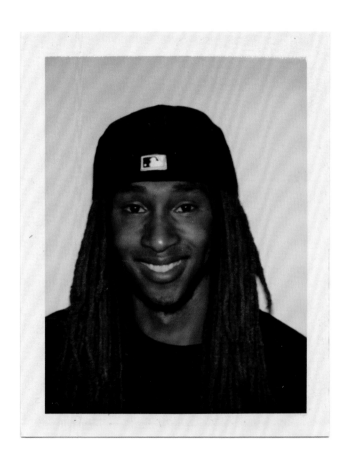

ANWAR CARROTS

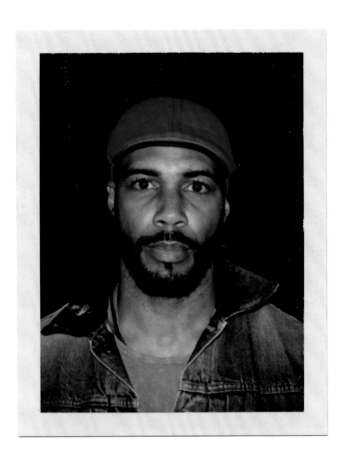

OMARI HARDWICK

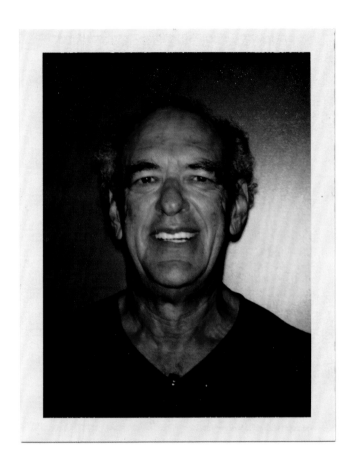

SHEP GORDON

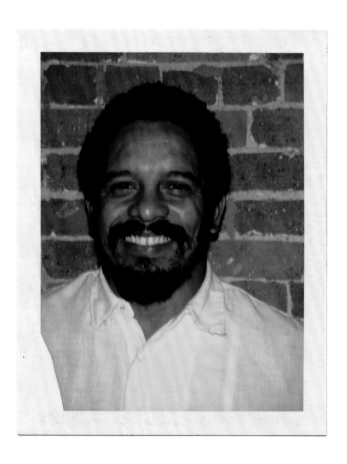

ROHAN MARLEY

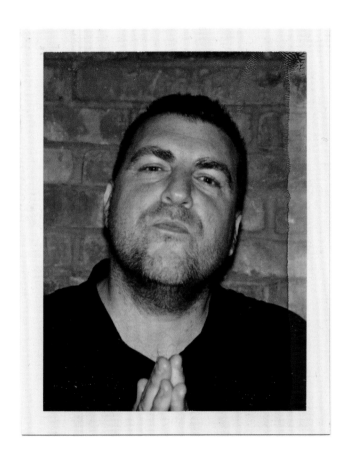

ROB STONE

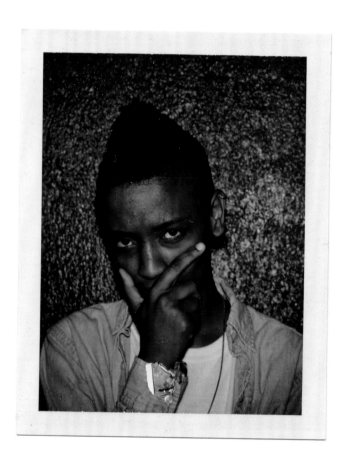

SYD THA KYD

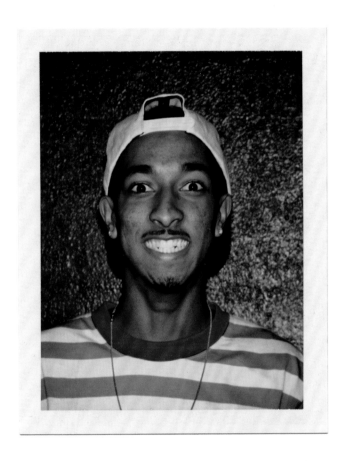

TACO OFWGKTA

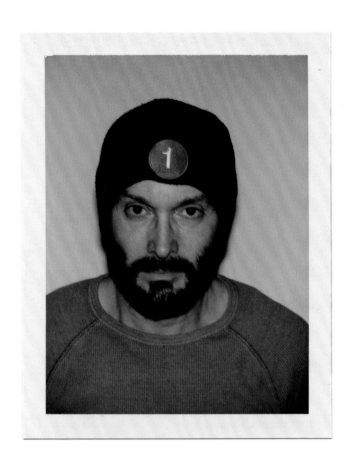

DREW STONE

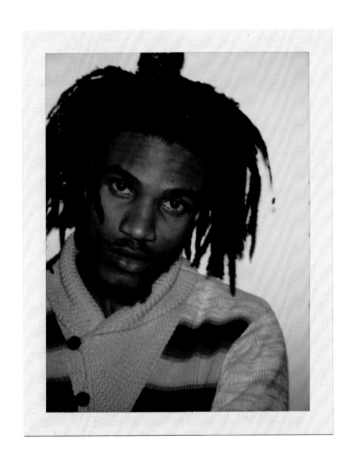

SHELDON SHEPARD

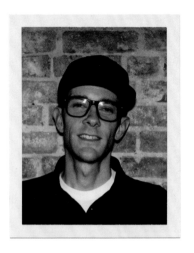

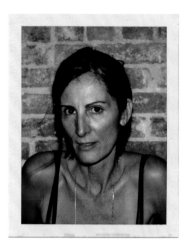

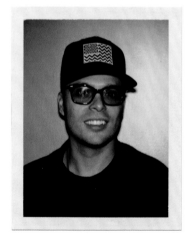

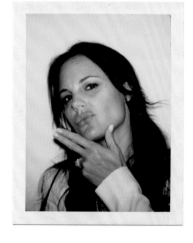

CHANCE LORD

RICHIE AKIVA

CHERYL DUNN

DEIRDRE MALONEY

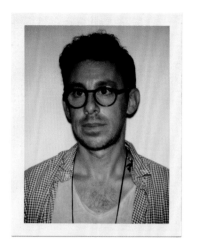

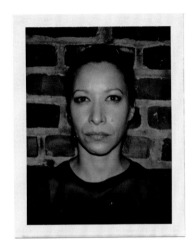

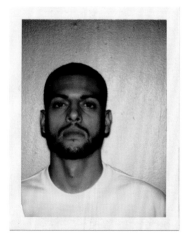

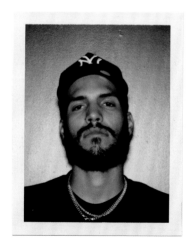

BILLY LEVY

STEVE MARTINEZ

LAURA HILL FLANAGAN

CHRISTIAN MARTINEZ

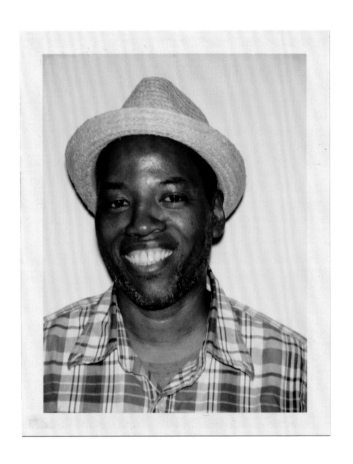

CEY ADAMS

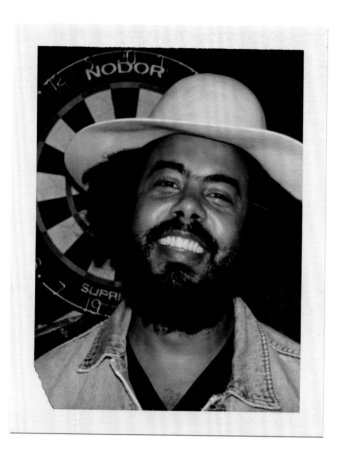

JILLIONAIRE

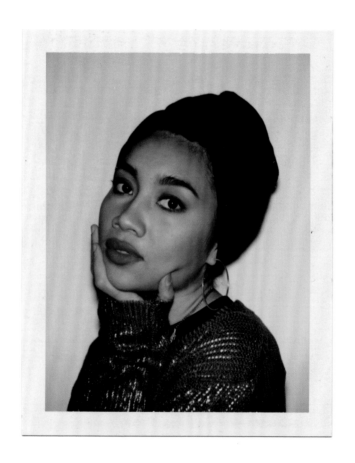

YUNA

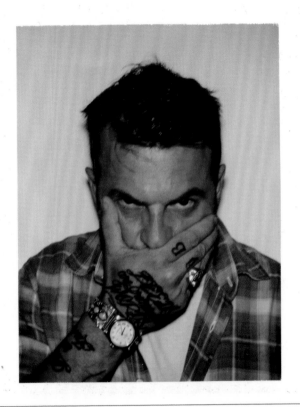

WYATT NEUMANN

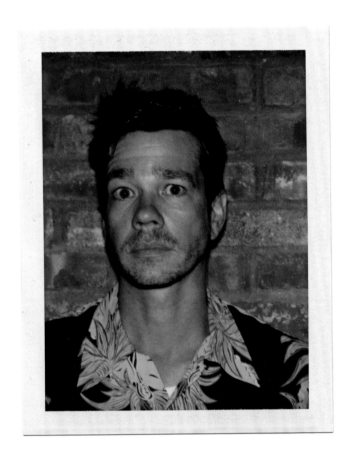

NATE RUESS

FAB 5 FREDDY

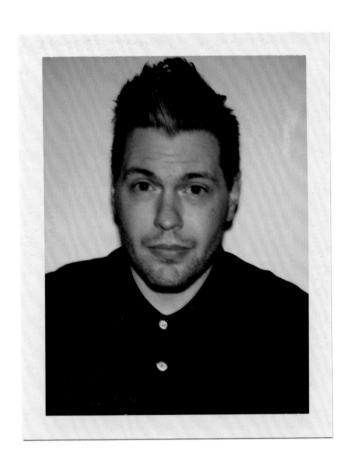

NOAH CALLAHAN-BEVER

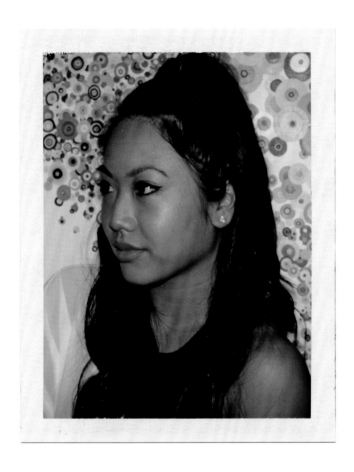

SUE TSAI

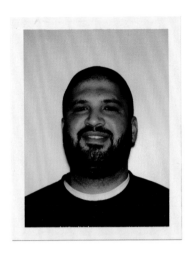
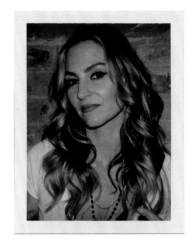
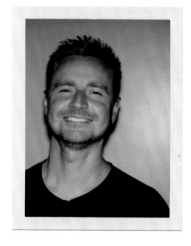
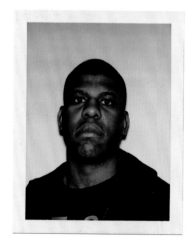

MISHA LOUY DREA DE MATTEO

CODY BURKE JOHN GRAY

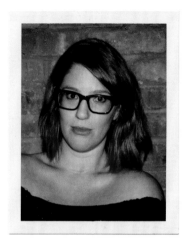
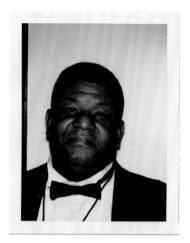
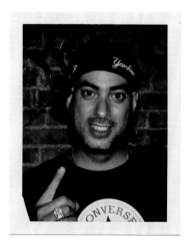
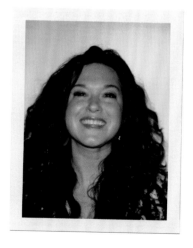

KATE ROSEN

DJ MARLON B

PHAROAH WILLIAMS

AVIVA YAEL

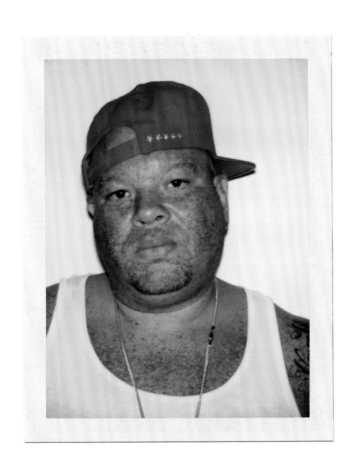

SHAWN "PECAS" COSTNER

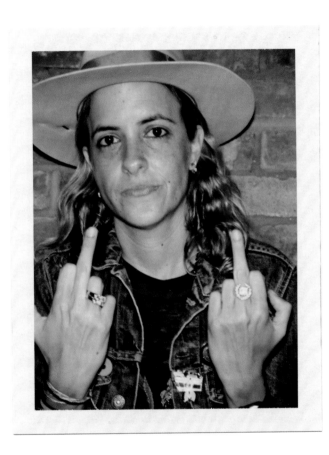

SAMANTHA RONSON

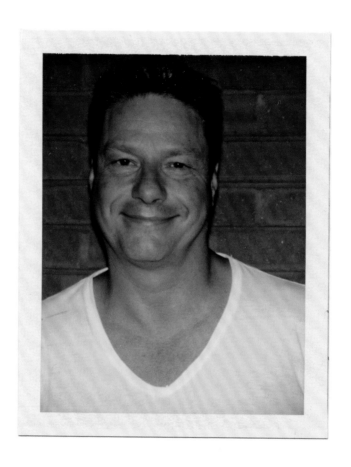

ARJAN ROSKAM

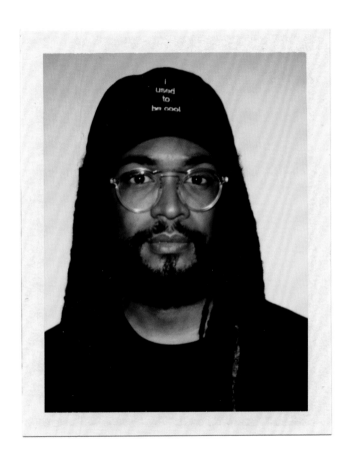

JAHPHET NEGAST LANDIS - ROOFEO

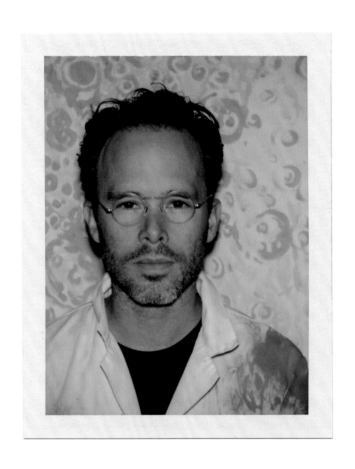

DANIEL ARSHAM

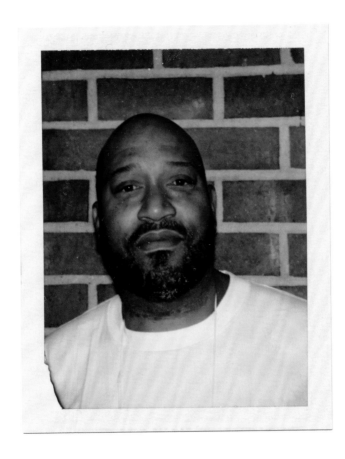

BUN B

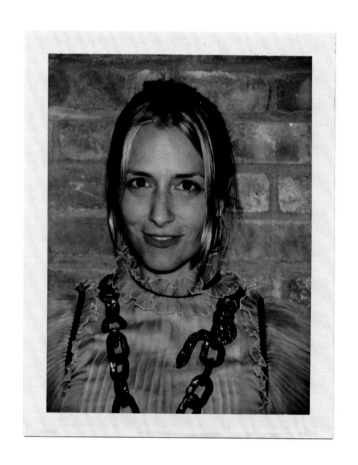

CHARLOTTE RONSON

AB LIVA

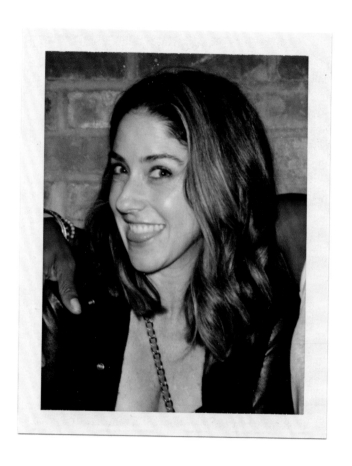

AMANDA SILVERMAN

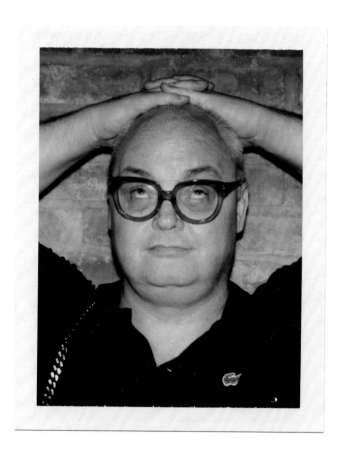

MICKEY BOARDMAN

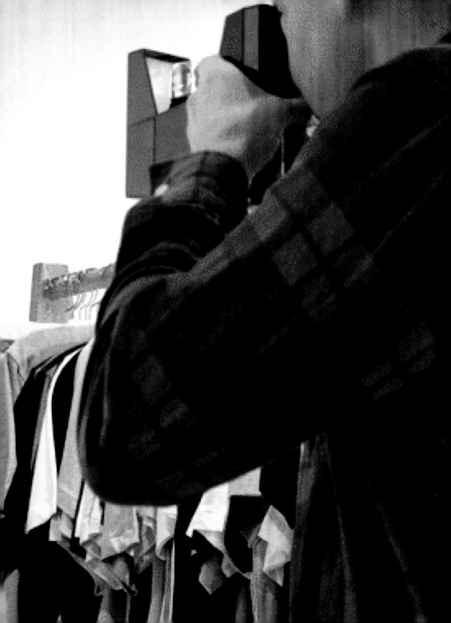